"Globes make my head spin. By the time I locate the place, they've changed the boundaries."

Monastery the H. Transfiguration
17001 Tomki Rd - (707) 485-8959
Redwood Valley, CA. 95470

War and Peace
in the Global Village
Marshall McLuhan
Quentin Fiore

Co-ordinated by Jerome Agel
Bantam Books New York London Toronto

brary of Congress Catalogue Number
-19249

ublished simultaneously in the
nited States and Canada

An inventory of some
of the current spastic
situations that could
be eliminated by
more feedforward

Years, a lifelong friend of Joyce's. Cranly lived all his mature life at the address of Leopold Bloom: 7 Eccles Street, Dublin. He spent his mature life in devising a cryptograph that would confer "the gift of perfect security upon the communications of all nations and all men." Kahn reports: "It required nothing more than a cigar box and a few bits of string and odds and ends for its operation." On page 135 of *Finnegans Wake*, Joyce describes his own verbal method, which is an exact parallel of Byrne's: "...can be built with glue and clippings, scrawled or voided on a buttress; the night express sings his story, the song of sparrownotes on his stave of wires;...." For anyone discouraged by Joyce's method, let him consider that it is no more than the habit of penetrating the mosaic forms of every environment, linguistic or geographic.

A propos our current struggle against the "Rising Tide of Communism":

The mechanizing process that began in the eighteenth century and led to the development of new service environments—the press, the highway, the postal routes—was soon augmented by steam and rail. By the middle of the nineteenth century the extent of environmental serv-

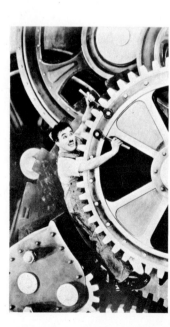

The frequent marginal quotes from *Finnegans Wake* serve a variety of functions. James Joyce's book is about the electrical retribalization of the West and the West's effect on the East:

> The west shall shake the east awake....
> while ye have the night for morn...

Joyce's title refers directly to the Orientalization of the West by electric technology and to the meeting of East and West. The *Wake* has many meanings, among them

the simple fact that in recoursing all of the human pasts our age has the distinction of doing it in increasing wakefulness.

Joyce was probably the only man ever to discover that all social changes are the effect of new technologies (self-amputations of our own being) on the order of our sensory lives. It is the shift in this order, altering the images that we make of ourselves and our world, that guarantees that every major technical innovation will so disturb our inner lives that wars necessarily result as misbegotten efforts to recover the old images.

There are ten thunders in the *Wake*. Each is a crypto-gram or codified explanation of the thundering and reverberating consequences of the major technological changes in all human history. When a tribal man hears thunder, he says, "What did he say that time?", as automatically as we say, "Gesundheit."

Joyce was not only the greatest behavioral engineer who ever lived, he was one of the funniest men, rearranging the most commonplace items to produce hilarity and insight: "Where the hand of man never set foot."

In *The Codebreakers*, David Kahn reveals a key item that seems to have eluded Joyce scholars. It concerns J. F. Byrne, the Cranly of *The Portrait*, the author of *Silent*

ices available to the workers of the community greatly exceeded the scale of services that could be monopolized by individual wealth. By Karl Marx's time, a "communism" resulting from such services so far surpassed the older private wealth and services contained within the new communal environment that it was quite natural for Marx to use it as a rear-view mirror for his Utopian hopes. The paradox of poverty amidst plenty had begun. Even the pauper lived, and lives, in an environment of multi-billion dollar communal services. Yet communal wealth developed by the mechanical extensions of man was soon outstripped by the electric services that began with the telegraph and which steadily enhanced the information environment. With the advent of an electric information environment, all the territorial aims and objectives of business and politics tended to become illusory. By now Communism is something that lies more than a century behind us, and we are deep into the new age of tribal involvement. Another paradox ensues; with electric technology, a backward country like the Soviet Union can bypass the older mechanical technologies. Backward countries can "turn on" with electricity, just as highly literate countries tend to "turn off."

Our Global Village:

It's possible, even today, to encounter highly educated people who are quite unaware that only phonetically literate man lives in a "rational" or "pictorial" space. The discovery or invention of such space that is uniform, continuous, and connected was an environmental effect of the phonetic alphabet in the sensory life of ancient Greece. This form of rational or pictorial space is an environment that results from no other form of writing, Hebraic, Arabic, or Chinese.

...experiencing a jolting series of prearranged disappointments, down the long lane of... generations, ...FW 107.

Now that we live in an electric environment of information coded not just in visual but in other sensory modes, it's natural that we now have new perceptions that destroy the monopoly and priority of visual space, making this older space look as bizarre as a medieval coat of arms over the door of a chemistry lab.

New environments inflict considerable pain on the perceiver. Biologists and physicists are much more aware of the radical revolution effected in our senses by new technological environments than are the literati, for whom the new environments are more threatening than for those in other disciplines.

The solid man saved by his sillied woman. Crackajolking away like a hearse on fire. FW 94.

When print was new in the sixteenth century, Hieronymus Bosch painted the new confusion of spaces resulting from the Gutenberg technology invasion of the old tactile world of medieval iconography. His "horror" pictures are a faithful artistic report of the pain and misery that result from a new technology. Even at the popular level, the confusion and pain created by radio in the twenties was lavishly expressed in the blues. Today, with television, a much more powerful medium, pain has

created musical genres from Rock to Beatle that are exceedingly unpleasant to sensibilities earlier oriented to less demanding technological environments. Today, the blues sound like caressing nursery lullabies. Their daring and sophisticated qualities are no more apparent than are those in a Victorian waltz.

...severalled
their four-
dimman-
sions.
FW 367.

The biologist Otto Lowenstein, in his book on *The Senses,* has some most helpful observations on the problems that arise upon any change in sensory mode, such as result from a technological creation of a new environment:

Each of our
senses is an
unique
world

> Seeing seems to be a rather calculating business, and all this makes one wonder whether one can ever "see" something of which one has had no previous knowledge. We gain this impression also from patients, blind from childhood, on whom normal vision has been bestowed by an operation. Previous to this "opening of the eyes," they had been living in a world of tactile experience, of sound and scent, full of objects familiar to them in terms of their restricted range of sensory experience. How they shrink at first from the welter of additional stimulation, longing at times to return to the relative seclusion of their former world! One of the most striking facts is that it takes a lot of time and effort before they recognize the objects around them as separate items. They have gradually to learn to "make sense of them" by associating their visual appearance with their tactile and other properties familiar to them. "At first sight" the world looks like a flat extension of meaningless patches of light, dark, and color jumbled up into a quilt work. One by one objects grow out of this chaotic world, and remain unmis-

"The
Senses,"
by Otto
Lowenstein.
Penguin
Books, Ltd.

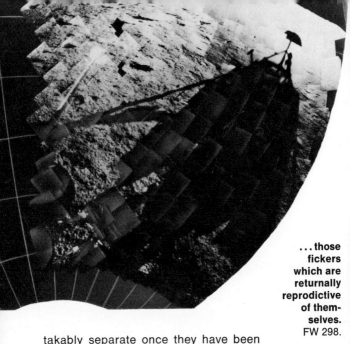

... those
fickers
which are
returnally
reprodictive
of them-
selves.
FW 298.

takably separate once they have been
identified. A student of microscopy
experiences something similar. A mean-
ingless jumble of shapes defies descrip-
tion, until the demonstrator has drawn
on paper one or the other specific
shapes to be searched for. The saying
"seeing is believing" may fittingly be
reversed in this context into "believing
is seeing."

What he says about "How they shrink at
first from the welter of additional stimula-
tion, longing at times to return to the rel-
ative seclusion of their former world" is
exactly the experience that every group
and individual feels when trying to adjust
to the unique sensory environment created
by a new technology. Today, electronics
and automation make mandatory that
everybody adjust to the vast global en-
vironment as if it were his little home town.

The artist is the only person who does not shrink from this challenge. He exults in the novelties of perception afforded by innovation. The pain that the ordinary person feels in perceiving the confusion is charged with thrills for the artist in the discovery of new boundaries and territories for the human spirit. He glories in the invention of new identities, corporate and private, that for the political and educational establishments, as for domestic life, bring anarchy and despair.

The biggest filing cabinet in the world.

"Theories of Personality," by Calvin S. Hall and Gardner Lindzey. John Wiley & Sons, Inc.

In *Theories of Personality,* Calvin S. Hall and Gardner Lindzey comment on the views of Gardner Murphy concerning this strange pattern by which people are always adjusted to the preceding environment, much as the General Staff is always superbly prepared to fight the last war:

Perceptual development goes through the three stages of *globality* during which the world is more or less a blur to the infant, *differentiation,* during which figures emerge from a background, and *integration,* during which perceptual patterns are formed. In keeping with Murphy's insistence upon the functional properties of all psychological processes, perception is guided by need, or to use his own vivid expression,

"Needs keep ahead of percepts." The motivational state exists first and exerts an influence upon the way in which the person will perceive the world.

Our man-made visual environment, which has persisted with various modulations of stress since the fifth century B.C., constitutes what we call the Western world. It's our own ingenuity and inventiveness that guarantee that this environment must now be superseded. Our consternation in facing this development is entirely of the "didn't know it was loaded" variety.

Lowenstein's comments on the flat quilt of patches of light and dark and color seen by the newly sighted is a very suitable indication of the motif of a great deal of contemporary art. As visual space is superseded, we discover that there is no continuity or connectedness, let alone depth and perspective, in any of the other senses. The modern artist—in music, in painting, in poetry—has been patiently expounding this fact for some decades, insisting that we educate our long neglected senses of touch and taste and hearing. Perhaps it is, above all, the sense of pain that the modern artist has discovered. Pain is a sense quite in addition to the usual five, and, as Lowenstein puts it, "we must assume that the central nervous system plays an overridingly important part in the elaboration of pain and suffering." Most of the pain felt by the occupants of new technological environments corresponds to what is medically called "phantom pain." The patient suffering it may have very definite notions about the source:

"There ought to be a law so a man knows whether he is doing right or wrong."
—Senator Thomas Dodd

 ... a patient suffering from severe phantom pain can only point in the direction

...and, an you could peep
inside the cerebralised sauce-
pan of this eer illwinded
goodfornobody, you would see
in his house of thoughtsam...
what a jetsam litterage of
convolvuli of times lost or
strayed, of lands derelict and
of tongues laggin too,... and
equally so, the crame of the
whole faustian fustian,...
though a day be as dense as
a decade,... FW 292.

of a long-lost limb to indicate its origin, and the intriguing phenomena of referred pain can add to the confusion. Referred pain often arises from impulses in one deep-seated organ, but is localized by the sufferer somewhere at the surface of the body.

The pain caused by new media and new technologies tends very much to fall into the category of "referred pain," such as skin trouble caused by the appendix or the heart. As with all new technologies, pain creates a special form of space, just as they also create pain. It's very much a case again of Heinrich Hertz' law: "The consequences of the images will be the images of the consequences."

All new technologies bring on the cultural blues, just as the old ones evoke phantom pain after they have disappeared.

In sensory terms, one might say that people like Charlie Chaplin and Thomas A. Edison, though great artists, were scarcely print-oriented. In later life, Edison, while still in possession of his sight, switched to Braille as preferable to visual reading. The great tactile involvement of Braille indicates that Edison had a sensibility that did not specialize in any one of the senses. Charlie Chaplin was so deeply aware of the processes of his art that he frequently acted his scenes backwards, leaving it to the technicians to run them frontwards. Tony Schwartz, a sound designer, has a tape of Chaplin pronouncing words and phrases backwards. When the technicians reversed these sounds, they came out as ordinary speech. Something similar to this fantastically involved sensory life is not compatible with a high degree of literacy.

The war is in words and the wood is the world.
FW 98.

Literacy is much too specialized for that. The electronic culture of the global village confronts us with a situation in which entire societies inter-communicate by a sort of "macroscopic gesticulation," which is not speech at all in the ordinary way. T. S. Eliot had mentioned this through the senses of his Sweeney: "I gotta use words when I talk to you."

A peak in a poke and a pig in a pew.
FW 273.

The extreme provinciality of our ideas of seeing is a simple result of living in a visual environment. Man-made environments are always unperceived by men during the period of their innovation. When they have been superseded by other environments, they tend to become visible.

We now see the visual world very plainly and begin to realize that other cultures, native and Oriental, have been developed on quite different sensory plans, for not only is each sense an unique world, but it offers unique pleasures and pains. Per-

The probe vs. a point of view. Total involvement vs. civilized detachment. (Photomicrograph of penis rods of a flea.)

haps our survival (certainly our comfort and happiness) depends upon our recognizing the nature of our new environment. It is sometimes blamed on the computer, which we have the habit of calling a "machine." This, of course, is pure rear-view mirrorism, seeing the old environment in the mirror of the new one while ignoring the new one. As Lowenstein indicates:

It may be said that, after all, man is not a robot, and therefore all this automatic gadgetry may be very little relevant to our understanding of postural and movement control. Nothing would be further from the truth.... the coordina-

We are all robots when uncritically involved with our technologies

The whool of the whaal in the wheel of the whorl of the Boubou from Bourneum has thus come to taon!),... FW 415.

tion of limb movement and body posture is almost entirely unconscious and automatic, and however complex the sensory structures involved, the information issuing from them hardly ever reaches the higher centers of the brain, but gives rise to what the biologist calls reflex reactions.

Man is not only a robot in his private reflexes but in his civilized behavior and in all his responses to the extensions of his body, which we call technology. The extensions of man with their ensuing environments, it's now fairly clear, are the principal area of manifestation of the evolutionary process.

When old the wormd was a gadden and Anthea first unfoiled her limbs wanderloot was the way the wood wagged where opter and apter were samuraised twimbs. FW 354.

With the extension of the nervous system itself as a new environment of electronic information, a new degree of critical awareness has become possible. Such critical awareness in the Western world, critiques and discriminations of the sensory life as expressed in our environments, has previously been the province of the artist only. The artist has been an alien and an outcast in the Western world until recently. Not so in the Orient, where the exact reverse has been the case for many centuries. But the Oriental world is a world that was never dedicated to fragmented or specialist stress on the visual sense. Art has been considered the primary mode of adjustment to the environment.

In *The Book of Tea* by Okakura-Kakuzo, the theme is that it is not tea but the ceremony that matters:

"The Book of Tea," by Okakura. Charles E. Tuttle Co., Inc.

> Even in that grotesque apology for Taoism which we find in China at the present day, we can revel in a wealth of imagery impossible to find in any other cult. But the chief contribution of Taoism to Asiatic life has been in the realm of aesthetics. Chinese historians have always spoken of Taoism as the "art of being in the world," for it deals with the present—ourselves. It is in us that God meets with Nature, and yesterday parts from tomorrow. The Present is the moving Infinity, the legitimate sphere of the Relative. Relativity seeks Adjustment; Adjustment is Art. The art of life lies in a constant readjustment to our surroundings.

Perhaps the nearest analogue to art in the Oriental sense appears in the Western world under the name of "fashion," which is treated later as "The Bore War."

Fashion, the rich man's foible, distracts him from distraction by distraction. Fashion is, as it were, the poor man's art, the usually unbought grace of life which he participates in only as a spectator. In sensory terms fashion has a kind of infallibility about it. As with hit tunes and hit pictures and hit entertainments, fashion rushes in to fill the vacuum in our senses created by technological displacements. Perhaps that is why it seems to be the expression of such a colossal preference while it lasts. James Joyce gives it a key role in *Finnegans Wake* in his section on the Prankquean. The Prankquean is the very expression of war and aggression. In her life, clothing is weaponry: "I'm the queen of the castle and you're the dirty rascal." In the very opening line of *Fin-*

Fashion as the poor man's art

But you'll love her for her hessians and sickly black stockies,... isn't it the cat's tonsils! Simply killing, how she tidies her hair! I call her Sosy because she's sosiety for me and she says sossy while I say sassy and she says will you have some more scorns while I say won't you take a few more schools...
FW 459.

negans Wake—"riverrun, past Eve and Adam's..."—Joyce thus indicates the reversal of nature that has taken place since the fall of man. It is not the world of Adam and Eve, but one in which there is priority of Eve over Adam. Clothing as weaponry had become a primary social factor. Clothing is anti-environmental, but it also creates a new environment. It is also anti-the elements and anti-enemies and anti-competitors and anti-boredom. As an adjustment to the world, it is mainly an adjustment to a world that has been made by fashions themselves and consists of imitations of older dress. As Lowenstein explained in his passage on sight as a quite arbitrary adjustment to a man-made world, fashion also has a kind of inevitability of sensory response to a man-made world.

He's herd of hoarding and her faiths is altared.
FW 331.

In a tribal or oral world there are no fashions in the sense of changing designs and fabrics. All clothing and all technol-

ogy is a part of a ritual that is desperately sought to be kept stabilized and permanent. An oral or tribal society has the means of stability far beyond anything possible to a visual or civilized and fragmented world. The oral and auditory are structured by a total and simultaneous field of relations describable as "acoustic space." Quite different is the visual world where special goals and points of view are natural and inevitable. Ashley Montagu explains it in *The Human Revolution:*

> The fact is that as man has advanced in civilization he has become increasingly, not less, violent and warlike. The violences that have been attributed to his original nature have, in fact, been acquired predominantly within the rela-

"The Human Revolution," by Ashley Montagu. The World Publishing Company. Copyright © 1965 by Ashley Montagu.

Here Comes Everybody

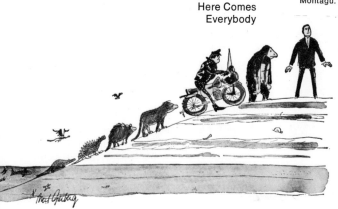

tively recent period of man's cultural evolution. In our own time most of us have grown so accustomed to the life of each for himself that it is difficult for us to understand that for the greater

24

The humming, it's coming. Insway onsway. FW 371.

part of man's history every man of necessity lived a life of involvement in the welfare of his fellows. If we have misinterpreted the life of prehistoric man and his prehuman ancestors through the distorting glass of our modern prejudices, there no longer remains any reason why we should continue to do so. The important thing for us is not to deny our prejudices and prejudgments, but to acknowledge them, and to consider the evidence concerning the nature of our prehuman ancestors in the light of facts.

Civilization, the mother of war

It helps to know that civilization is entirely the product of phonetic literacy, and as it dissolves with the electronic revolution, we rediscover a tribal, integral awareness

that manifests itself in a complete shift in our sensory lives.

If the Greeks had achieved Euclidean space and visual specialism in their sensory lives, they were greatly outdistanced in this matter by the Romans. In *The Beginnings of Architecture* Sigfried Giedion explains how the Romans were the first people to enclose space, the first to achieve what is genuine pictorial space, architecturally. This occurred in the Roman arch. Neither the Greeks nor any earlier society had ever discovered the arch. This is a very technical matter and can be bypassed for the moment, since nobody questions the Roman obsession with visual organization of space. There is a great gap between Greek and Roman culture, and it may well have had much to do with the innovation of papyrus in the Roman world, for papyrus intensified visual culture beyond anything ever achieved by man before Gutenberg.

The equally spectacular gap between Roman and medieval culture may have been occasioned by the disappearance of the supplies of papyrus and the ensuing slumps in visual values. A large wave of Egyptian nationalism submerged the papyrus industry and forbade its export to the Romans. The only person who seems to have paid much attention to this is Harold Innis in his *The Bias of Communication* (University of Toronto Press). The Greeks had not any papyrus materials and so they were not inclined to build the road systems that papyrus, and later paper, strongly support. Papyrus being a very light and transportable medium was also cheap and abundant enough for everyday use.

Naturally, it was the Roman military that found it most useful. Wedded to the phonetic alphabet, papyrus was the means of creating their huge networks of straight roads which gave a special character to their military activities. Papyrus meant control and direction of armies at a distance from a central bureaucracy. No such resource had been available to Alexander the Great or to any Greek generals.

All's fair on all fours,... FW 295.

The Roman roads ensured high speeds of military maneuvers and made possible the carrying of large quantities of supplies on campaigns. When papyrus ceased to be available (imagine the effect of the total disappearance of crude oil on our road system, our traffic and our central heating), the Roman roads fell into disuse and the Roman Empire fell apart. A little further on, the military substitute for roads and couriers and wagons and chariots will be described with the help of Lynn White. Having their straight and even roads, the Romans did not have the same need for mounted men who could traverse uneven terrain. Perhaps this was why they relied on the chariot rather than cavalry for those who wore heavy armor. With the disappearance of the roads and the chariots, a radical new substitute had to be devised for those who had need of heavy armor in battle. That substitute was the stirrup.

The stirrup as a way up in the world

If literate people are reluctant to consider how the ground rules of their world have been laid down by phonetic literacy, they might find some comfort in the quite hilarious description of *Medieval Technology and Social Change* by Lynn White. He

considers that it was early in the eighth century, well after the Roman collapse (through the drying up of papyrus supplies), that the stirrup was introduced into the West from some obscure Oriental source. The stirrup made it possible for a man in *heavy* armor to be mounted on a horse. No such thing had been possible for the Greeks or Romans.

To make a heavy suit of armor required the work of a skilled craftsman for an entire year. This proved so expensive that it called for an entire reshaping of the economy. If there were to be mounted armed knights, they then had to have means of paying for their equipment. Since a suit of armor required not only the work of the craftsman but involved many other expenses for horses and squire, it was found expedient to switch the entire system of land-holding from the traditional strip-farming to a quite different pattern, which affected the entire social structure. Mr. White tells the story very succinctly.

Fighting in the new manner involved large expenditures. Horses were costly, and armor was growing heavier to meet the new violence of mounted shock combat. In 761 a certain Isanhard sold his ancestral lands and a slave for a horse and a sword. In general, military equipment for one man seems to have cost about twenty oxen, or the plough-teams of at least ten peasant families. But horses get killed: a knight needed remounts to be effective; and his squire should be adequately mounted. And horses eat large quantities of grain, an important matter in an age of more slender agricultural production than ours.

Down with the Saozon ruze! And I am afraid it wouldn't be my first coat's wasting after striding on the vampire ... Impregnable as the mule himself. FW 411.

"Medieval Technology and Social Change," by Lynn White. Clarendon Press, Oxford.

Although in the Frankish realm the right and duty to bear arms rested on all free men regardless of economic condition, naturally the great majority could afford to come to muster only on foot, equipped with relatively inexpensive weapons and armor.... [Mr. White continues]... As has been mentioned, even from this group Charlemagne tried to raise horsemen by commanding that the less prosperous freemen should band together, according to the size of their lands, to equip one of their number and send him to the wars. Such an arrangement would be hard to administer, and it did not survive the confusion of the later ninth century. But inherent in this device was the recognition that if the new technology of warfare were to be developed consistently, military service must become a matter of class. Those economically unable to fight on horseback suffered from a social infirmity which shortly became a legal inferiority. In 808 the infelicitous wording of a capitulary *De exercitu promovendo* distinguishes "liberi" from "pauperes": the expression is legally inexact, but it points to the time when freedom was to become largely a matter of property. Two capitularies of 825 show how rapidly concepts were moving. One separates "liberi" from "mediocres quippe liberi qui non possunt per se hostem facere"; while the other refers to those latter as "liberi secundi ordinis."

With the collapse of the Frankish empire, the feudality which the Carolingians had deliberately created, in terms of the new military method of mounted shock combat, to be the backbone of their army became the governing as well as the fighting *elite*.

The stirrup that led to the armor abolished

The specks on his lap-span are his foul deed thougths, wishmarks of mad imogenation. Take they off! Make the off!
FW 251.

the yeoman's small holdings in favor of the lordly domain and created the same revolution that occurred in America—small farmer to lordly corporation. It was far from being a quantitative change. Mr. White continues:

> The chivalric class never repudiated the original condition of its existence: that it was endowed to fight, and that anyone who could not or would not meet his military obligations forfeited his endowment. The duty of knight's service is the key to feudal institutions. It is "the touchstone of feudalism, for through it all else was drawn into focus; and its acceptance as the determining principle of land-tenure involved a social revolution."

The feudal sense that the enjoyment of wealth is inseparable from public responsibility chiefly distinguishes medieval ideas of ownership from both classical and modern. The vassal class created by the military mutation of the eighth century became for generations the ruling element of European society, but through all subsequent chaos, and despite abuses, it never lost completely its sense of *noblesse oblige,* even when a new and rival class of burghers revived the Roman notion of the unconditional and socially irresponsible possession of property.

(Oop, I never open momouth but I pack mefood in it) ... Stamp out bad eggs. FW 437.

In *The Incas,* Alfred Metraux notes: "At nightfall on Nov. 16, 1532, the Inca Atahualpa, surrounded by his bodyguards, was snatched from his litter and taken prisoner by Francisco Pizarro. His army, cut to pieces by a handful of horsemen, disappeared into the darkness. In barely three hours the power of the greatest pre-Columbian state of America had been decisively broken. The fall of the Inca empire led to the death of a civilization whose greatness had been perceived even by the rude adventurers who destroyed it."

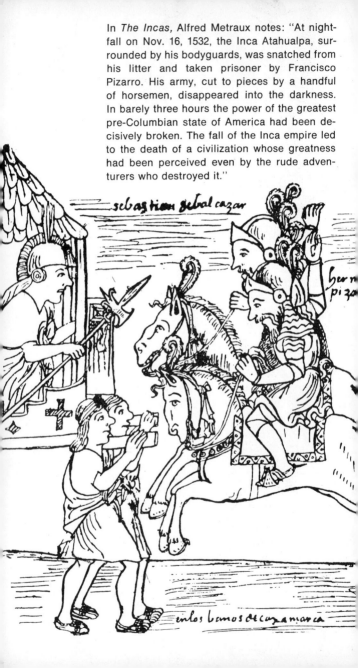

The second element in a knight's pride, prowess, was inherent in the adequate performance of his service. Quite apart from the cost of arms and horses, the new mode of fighting necessarily destroyed the old Germanic idea that every freeman was a soldier. Mounted shock combat was not a business for part-time warriors: one had to be a skilled professional, the product of a long technical training, and in excellent physical condition....

The end of the freeman as a soldier

As the violence of shock combat increased, the armorer's skill tried to meet it by building heavier and heavier defenses for the knight. Increasingly he became unrecognizable beneath his carapace, and means of identification had to be developed. In the Bayeux Tapestry of the late eleventh century the pennons are more individualized than the shields. By the early twelfth century, however, not only armorial devices but hereditary arms were coming into use in France, England, and Germany. It is not playing tricks with semantics to insist that the feudal knight himself, and his society, knew who he was in terms of his arms. The exigencies of mounted shock combat, as invented by the Franks of the eighth century, had formed both his personality and his world.

Look at that for a riding-pin! FW 419.

The flowering of the knightly stirrup does not end here. It was planted in English soil by William the Conqueror in a memorable way and on a memorable date. Let us keep 1066 and all that firmly in mind:

Sport's a common thing. It was the Lord's own day for damp (to wait for a postponed regatta's eventualising is not of Battlecock Shettledore-Juxta-Mare only) and the request for a fully armed explanation... FW 51.

At Hastings the Anglo-Saxons had the advantage of position on the hill of Senlac; they probably outnumbered the Normans; they had the psychological strength of fighting to repel invaders of their homeland. Yet the outcome was

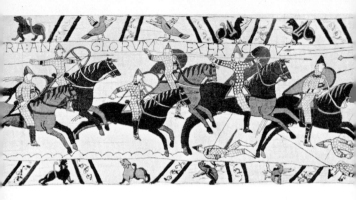

certain: this was a conflict between the military methods of the seventh century and those of the eleventh century. Harold fought without cavalry and had few archers. Even the English shields were obsolete: the Bayeux Tapestry shows us that while the royal bodyguard fought with kite-shaped shields—probably a result of Edward the Confessor's continental education—most of the Anglo-Saxons were equipped with round or oval shields. From the beginning William held the initiative with his bowmen and cavalry, and the English could do nothing but stand and resist a mobile striking power which at last proved irresistible.

Toborrow and toburrow and tobarrow! That's our crass, hairy and evergrim life,... FW 455.

When William had won his victory and the crown of England, he rapidly modernized, i.e. feudalized, his new kingdom. Naturally he preserved and incorporated into the Anglo-Norman order whatever institutions of the Anglo-Saxon régime suited his purpose; but innovation was more evident than continuity.

There is an old saying that Britons never shall be Slavs, but they did become the robots of a new gimmick:

Indeed, the England of the later eleventh century furnishes the classic example in European history of the disruption of a social order by the sudden introduction of an alien military technology. The Norman Conquest is likewise the Norman Revolution. But it was merely the spread across the Channel of a revolution which had been accomplished by stages on the Continent during the preceding ten generations.

Few inventions have been so simple as the stirrup, but few have had so catalytic an influence on history. The requirements of the new mode of warfare which it made possible found expression in a new form of western European society dominated by an aristocracy of warriors endowed with land so that they might fight in a new and highly specialized way. Inevitably this nobility developed cultural forms and patterns of thought and emotion in harmony with its style of mounted shock combat and its social posture; as Denholm-Young has said: "It is impossible to be chivalrous without a horse." The Man on Horse-

He beached
the bark
of his tale . . .
FW 358.

They ought
to told
you every
last word
first stead
of trying
every which
way to
kinder
smear it
out poison
long.
FW 283.

back, as we have known him during the past millennium, was made possible by the stirrup, which joined man and steed into a fighting organism. Antiquity imagined the Centaur; the early Middle Ages made him the master of Europe.

The invention of gunpowder simply blew this armor right off the backs of the knights and made the entire feudal system redundant. (This revolution, however, is puny compared to the effects of automation today.) That didn't prevent it from continuing for some centuries until Cromwell transferred the knights' armor to his corporate "Ironsides," who were very much the by-product of Gutenberg's mov-

able types. Gutenberg technology is the only one mentioned by Carlyle in *Sartor Resartus* as a form of social clothing. He ignored all the amazing new clothing and hardware of the industrial age that surrounded him. On somewhat the same pattern Darwin and Marx ignored the manmade environments in their theories of evolution and causality in favor of the eighteenth century and romantic idea of nature as environment. Medieval armor surely represents a happy wedding of technology and clothing and weaponry, and Lynn White has shown how directly it affects the institutional clothing of education and politics that emerged directly from it. We might wish there were some equally simple way of showing how similar changes are inherent in any technological innovation whatever.

The computer is by all odds the most extraordinary of all the technological clothing ever devised by man, since it is the extension of our central nervous system. Beside it, the wheel is a mere hula-hoop, though that is not to be dismissed entirely. For example, a mere forty years ago the hoop was a main pastime for the young, but they rolled it down the street and never thought of putting it on as a dancing costume. The television generation of youngsters have never been known to roll a hula-hoop, even when urged by their elders. In dancing it, they express a totally new sensibility and awareness of involvement in form.

The new feeling for the hula-hoop compared to the Tom Sawyer-attitude toward the hoop is an example of what Otto Lowenstein describes in his remarkable

The way to
keep up is
to be ahead.
(Start with
the "other"
man's
ignorance —
not his
knowledge.)

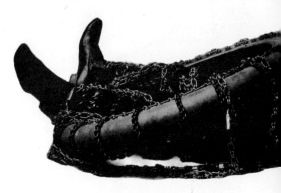

account of what the newly sighted per-
ceive in the world outside them. The in-
formation environment and effects created
by the computer are as inaccessible to
literate vision as the external world is to
the blind. For example, the computer has
made possible our satellites which have
put a man-made environment around the
planet, ending "nature" in the older sense.
The new information technology will
shortly encompass the entire astral sys-
tem, harnessing its resources for terres-
trial use. The important thing is to realize
that electric information systems are live
environments in the full organic sense.
They alter our feelings and sensibilities,
especially when they are not attended to.
"Yes, the viability of vicinals if invisible
is invincible." (FW 81)

This is a principle that applies to all tech-
nologies whatever, explaining the pathos
and impercipience of historical man.
Since the new information environments
are direct extensions of our own nervous
system, they have a much more profound

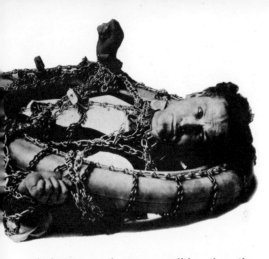

relation to our human condition than the old "natural" environment. They are a form of clothing that can be programmed at will to produce any effect desired. Quite naturally, they take over the evolutionary work that Darwin had seen in the spontaneities of biology.

Technologically, the principal developments between the battle of Hastings and the battle of Naseby were the gunpowder and the Gutenberg revolutions. Both of these revolutions are still resonating in our daily lives. Perhaps full credit has not been given to the gunpowder principle in relation to the motor car. Exploding gunpowder in a cylinder is the main principle of the internal combustion engine, which had a very archaic aspect even in its beginnings. The electric circuit added to the musket, as it were, was the hybrid that produced the motor car. At the battle of Naseby (1645) most of the medieval technology was present and dominant. Cromwell, however, had created a new regimental structure for his foot soldiers,

Indifference of military historians to the effects of technology

transferring the Gutenberg principle of lineality to human organization. His Ironsides were a sort of simulation of individual medieval armor in corporate form. A student of military technology will find it difficult to discover any analysis of domestic technical innovation as it affected military operations. Military historians are

visually oriented people who are fond of making romantic landscapes in which they can deploy forces like any Hollywood producer. John Viscount Morley has a few indications of the technical changes available to Cromwell. It will be useful to quote all that he has to say on this subject in *Oliver Cromwell:*

"Oliver Cromwell," by John Morley. Macmillan & Co. Ltd.

The temper of the time was hard, men were ready to settle truth by blows, and life, as in the Middle Ages, was still held cheap. The cavalier was hot, unruly, scornful, with all the feudal readiness for bloodshed. The roundhead was keen, stubborn, dogged, sustained by the thought of the heroes of the Old Testament who avenged upon Canaanite and Amalekite the cause of Jehovah.

Men lived and fought in the spirit of the Old Testament and not of the New. To men of the mild and reflecting temper of Chillingworth the choice was no more cheerful than between publicans and sinners on one side, and scribes and Pharisees on the other. A fine instance of the high and manly temper in which the best man entered upon the struggle is to be found in the words used by Sir William Waller to the brave Hopton. "God, who is the searcher of my heart," Waller wrote, "knows with what a sad sense I go upon this service, and with what a perfect hatred I detest this war without an enemy; but I look upon it as sent from God, and that is enough to silence all passion in me. . . . We are both upon the stage, and must act such parts as are assigned us in this tragedy. Let us do it in a way of honor and without personal animosities.". . .

It is not within my scope to follow in detail the military operations of the civil war. For many months they were little more than a series of confused marches, random skirmishes, and casual leaguers of indecisive places. Of generalship, of strategic system, of ingenuity in scientific tactics, in the early stages there was little or none. Soldiers appeared on both sides who had served abroad, and as the armed struggle developed, the great changes in tactics made by Gus-

tavus Adolphus quickly found their way into the operations of the English war. He suppressed all caracoling and parade maneuvers. Cavalry that had formed itself in as many as five or even eight ranks deep was henceforth never marshalled deeper than three ranks, while in the intervening spaces were platoons of foot and light field-pieces. All this, the soldiers tell us, gave prodigious mobility, and made the Swedish period the most remarkable in the Thirty Years War. But for some time training on the continent of Europe seems to have been of little use in the conflicts of two great bands of military, mainly rustic among the hills and downs, the lanes and hedges, the rivers and strong places of England. Modern soldiers have noticed as one of the most curious features of the civil war how ignorant each side usually was of the doing, position, and designs of its opponents. Essex stumbled upon the king, Hopton stumbled upon Waller, the king stumbled upon Sir Thomas Fairfax. The two sides drew up in front of one another, foot in the center, horse on the wings; and then they fell to and hammered one another as hard as they could, and they who hammered hardest and stood to it longest won the day. This was the story of the early engagements.

Armor was fallen into disuse, partly owing to the introduction of firearms, partly perhaps for the reason that pleased King James I — because besides protecting the wearer, it also hindered him from hurting other people. The archer had only just disappeared, and arrows were shot by the English as late as at the Isle of Ré in 1627. Indeed, at the outbreak of the war Essex issued a precept for raising a company of archers, and in Montrose's campaign in

Scotland bowmen are often mentioned. It is curious to modern ears to learn that some of the strongest laws enjoining practice with bow and arrow should have been passed after the invention of gunpowder, and for long there were many who persisted in liking the bow better than the musket, for the whiz of the arrow over their heads kept the horses in terror, and a few horses wounded by arrows sticking in them were made unruly enough to disorder a whole squadron. A flight of arrows, again, apart from those whom they killed or wounded, demoralized the rest as they watched them hurtling through the air. Extreme conservatives made a judicious mixture between the old time and the new by firing arrows out of muskets. The gunpowder of those days was so weak that one homely piece of advice to the pistoleer was that he should not discharge his weapon until he could press the barrel close upon the body of his enemy, under the cuirass if possible; then he would be sure not to waste his charge. The old-fashioned musket-rest disappeared during the course of the war. The shotmen, the musketeers and harquebusiers, seem from 1644 to have been to pikemen in the proportion of two to one. It was to the pike and the sword that the hardest work fell. The steel head of the pike was well-fastened upon a strong, straight, yet nimble stock of ash, the whole not less than seventeen or eighteen feet long. It was not until the end of the century that, alike in England and France, the pike was laid aside and the bayonet used in its place. The snaphance or flintlock was little used, at least in the early stages of the war, and the provision of the slow match was one of the difficulties of the armament. Clarendon mentions that in one of

the leaguers the besieged were driven to use all the cord of all the beds of the town, steep it in saltpeter, and serve it to the soldiers for match. Cartridges though not unknown were not used in the civil war, and the musketeer went into action with his match slowly burning and a couple of bullets in his mouth. Artillery, partly from the weakness of the powder, partly from the primitive construction of the mortars·and cannon, was a comparatively ineffective arm upon the field, though it was causing a gradual change in fortifications from walls to earthworks. At Naseby the king had only two demi-cannon, as many demi-culverins, and eight sakers. The first weighed something over four thousand pounds, and shot twenty-four pounds. The demi-culverin was a twelve- or nine-pounder. The saker was a brass gun weighing fifteen hundred pounds, with a shot of six or seven pounds.

.It was not, however, upon guns any more than upon muskets that the English commander of that age relied in battle for bearing the brunt, whether of attack or of defense. He depended upon his horsemen, either cuirassiers or the newly introduced species, the dragoons, whom it puzzled the military writer of that century whether to describe as horse-footmen or foot-horsemen. Gustavus Adolphus had discovered or created the value of cavalry, and in the English civil war the campaigns were few in which the shock of horse was not the deciding element. Cromwell with his quick sagacity perceived this in anticipation of the lessons of experience. He got a Dutch officer to teach him drill, and his first military proceeding was to raise a troop of horse in his own countryside and diligently fit them for action.

As Ollover Krumwall sayed when he slepped ueber his grannyamother. Kangaroose feathers. Who in the name of thunder'd ever belevin you were that bolt? FW 299.

If the preceding selections from White and Morley are considered as indications of an evolution in human instruments that had a very deep effect on human institutions, the student may be able the better to train his perceptions to apprehend a myriad of adjacent problems and developments that were concurrent with these. Armor and weaponry as a form of human clothing are also reminders that clothing is itself a systematic form of aggression.

Edmund Burke was situated in a period of the first mechanical, industrial development and steam power. His alienation from these new forms was as vivid as that of Blake or Shelley. However, his recorded responses to the developments of his age make a finale to the feudal period as grandiose as anything in Buxtehude or Bach. In *Reflections on the Revolution in France,* he clad the entire development in a rhetorical costume that has survived as well as any armor:

In a moment of indisposition, Dr. Johnson said to his friends, "If Burke were here now, it would kill me." He referred to the power of Burke's discourse

"Reflections on the Revolution in France," by Edmund Burke. Rinehart edition edited by William B. Todd. Holt, Rinehart, Winston, Inc., publishers.

The moment you abate anything from the full rights of men, each to govern himself, and suffer any artificial positive limitation upon those rights, from that moment the whole organization of government becomes a consideration of convenience. This it is which makes the constitution of a state, and the due distribution of its powers, a matter of the most delicate and complicated skill. It requires a deep knowledge of human nature and human necessities, and of the things which facilitate or obstruct the various ends which are to be pursued by the mechanism of civil institutions. The state is to have recruits to its strength, and remedies to its distempers. What is the use of discussing a man's abstract right to food or to medi-

cine? The question is upon the method of procuring and administering them. In that deliberation I shall always advise to call in the aid of the farmer and the physician, rather than the professor of metaphysics.

"Many of the new ideas can be expressed in-non-mathematical language, but they are none the less difficult on that account. What is demanded is a change in our imaginative picture of the world...."
—Bertrand Russell.

The science of constructing a commonwealth, or renovating it, or reforming it, is, like every other experimental science, not to be taught *a priori*. Nor is it a short experience that can instruct us in that practical science; because the real effects of moral causes are not always immediate; but that which in the first instance is prejudicial may be excellent in its remoter operation; and its excellence may arise even from the ill

What the thunders said...

Thunder 1: Paleolithic to Neolithic. Speech. Split of East/West. From herding to harnessing animals.

baba bad babble. Black sheep, Ali Baba.

**bababadalgharaghtakamminarronnkonnbronntonnerronn
tuonnthunntrovarrhounawnskawntoohoohoordenenthurnuk!**

Thunder 2: Clothing as weaponry. Enclosure of private parts. First social aggression.

kod husk

**Perkodhuskurunbarggruauyagokgorlayorgromgremmit
ghundhurthrumathunaradidillifaititillibumullunukkunun!**

Thunder 3: Specialism. Centralism via wheel, transport, cities: civil life.

klik of wheel clique in society. **klas**

klikkaklakklaskaklopatzklatschabattacreppycrottygrad

Blady bloody. **ughfoul** awful. **moecklenburg** Mucktown.

Bladyughfoulmoecklenburgwhurawhorascortastrumpapo
rnanennykocksapastippapatuppperstrippuckputtanach

Thunder 5: Printing. Distortion and translation of human patterns and postures and pastors.
Thing crookly ex in every pasture

Thingcrooklyexineverypasturesixdixlikencehimaroundh
ersthemaggerbykinkinkankanwithdownmindlookingated.

Thunder 6: Industrial Revolution. Extreme development of print process and individualism.
Lukkedoeren locked doors. The Phoenix Playhouse in which exhibitionist masks are supreme.

Lukkedoerendunandrrraskewdylooshoofermoyportertoory
zooysphalnabortansporthaokansakroidverjkapakkapuk.

Thunder 7: Tribal man again.
Both all choractors end of separate, private man. Return of choric.

Bothallchoractorschumminaroundgansumuminarumdrums
trumtruminahumptadumpwaultopoofoolooderamaunsturnup!

Thunder 8: Movies. Pop art, pop Kulch via tribal radio. Wedding of sight and sound.
Pappa apparras big guy again projected on arras.

**Pappappapparrassannuaragheallachnatullaghmonganmac
macmacwhackfalltherdebblenonthedubblandaddydoodled**

Thunder 9: Car and plane. Both centralizing and decentralizing at once create cities in crisis. Speed and death.
hussten hassten caffin [caffeine] coffin

**husstenhasstencaffincoffintussemtossemdamandamnacqs
aghcusaghhobixhatouxpeswchbechoscashlcarcarcaract**

Thunder 10: Television. Back to tribal involvement in primal mood-mud. Last thunder = turbulent, muddy wake, and murk of non-visual, tactile man.
Ullodturdenweirmudgaardgring hello turd (toured, toward) ford—mud-mood gathering.

**Ullhodturdenweirmudgaardgringnirurdrmolnirfenrirlu
kkilokkibaugimandodrrerinsurtkrinmgernnrackinarockar!**

effects it produces in the beginning. The reverse also happens; and very plausible schemes with very pleasing commencements have often shameful and lamentable conclusions. In states there are often some obscure and almost latent causes, things which appear at first view of little moment, on which a very great part of its prosperity or adversity may most essentially depend. The science of government being therefore so practical in itself, and intended for such practical purposes, a matter which requires experience, and even more experience than any person can gain in his whole life, however, sagacious and observing he may be, it is with infinite caution that any man ought to venture upon pulling down an edifice which has answered in any tolerable degree for ages the common purposes of society, or on building it up again, without having models and patterns of approved utility before his eyes.

Elsewhere in this treatise Burke makes an observation that anticipates the computer age, saying that the first right of every man in civilized society is the right to be protected against the consequences of his own stupidity.

In the new age of Malthus and Adam Smith, the quantifying principle was increasingly prevalent. It implied a fragmentation of human sensibility of an extreme kind, and Burke comments on this theme just before bidding farewell to what he felt had been, relatively speaking, a period of integral existence: "Political reason is a computing principle; adding, subtracting, multiplying, and dividing, morally and not metaphysically or mathematically, true moral denominations." His vision of the

departing civilization, as Tom Macaulay would have said, is familiar to every schoolboy:

It is now sixteen or seventeen years since I saw the queen of France, then the dauphiness, at Versailles; and surely never lighted on this orb, which she hardly seemed to touch, a more delightful vision. I saw her just above the horizon, decorating and cheering the elevated sphere she just began to move in,—glittering like the morning-star, full of life, and splendor, and joy. Oh! what

a revolution! and what an heart must I have, to contemplate without emotion that elevation and that fall! Little did I dream when she added titles of veneration to those of enthusiastic, distant, respectful love, that she should ever be obliged to carry the sharp antidote against disgrace concealed in that bosom; little did I dream that I should have lived to see such disasters fallen upon her in a nation of gallant men, in a nation of men of honor and of cavaliers. I thought ten thousand swords must have leaped from their scabbards to avenge even a look that threatened her with insult.—But the age of chivalry is gone.—That of sophisters, economists and calculators, has succeeded; and the glory of Europe is extinguished forever. Never, never more, shall we behold that generous loyalty to rank and sex, that proud submission, that dignified obedience, that subordination of the heart, which kept alive, even in servitude itself, the spirit of an exalted freedom. The unbought grace of life, the cheap defense of nations, the nurse of manly sentiment and heroic enterprise is gone! It is gone, that sensibility of principle, that chastity of honor, which felt a stain like a wound, which inspired courage whilst it mitigated ferocity, which ennobled whatever it touched, and under which vice itself lost half its evil, by losing all its grossness.

This mixed system of opinion and sentiment had its origin in the ancient chivalry; and the principle, though varied in its appearance by the varying state of human affairs, subsisted and influenced through a long succession of generations, even to the time we live in. If it should ever be totally extinguished, the loss I fear will be great. It is this which has given its character to

You may fail to see the lie of that layout ... She'll confess it by her figure and she'll deny it to your face.
FW 271.

For a burning would is come to dance inane.
FW 250.

modern Europe. It is this which has distinguished it under all its forms of government, and distinguished it to its advantage, from the states of Asia, and possibly from those states which flourished in the most brilliant periods of the antique world....

But now all is to be changed. All the pleasing illusions, which made power gentle, and obedience liberal, which harmonized the different shades of life, and which, by a blind assimilation, incorporated into politics the sentiments which beautify and soften private society, are to be dissolved by this new conquering empire of light and reason. All the decent drapery of life is to be rudely torn off. All the superadded ideas, furnished from the wardrobe of a moral imagination, which the heart owns, and the understanding ratifies, as necessary to cover the defects of our naked shivering nature, and to raise it to dignity in our own estimation, are to be exploded as a ridiculous, absurd and antiquated fashion.

Various people have pointed out that the computer revolution is greater than that of the wheel in its power to reshape human outlook and human organization. Whereas the wheel is an extension of the foot, the computer gives us a world where the hand of man never set foot. (James Joyce made many such observations. He once said: "I am the greatest engineer who ever lived." When his work is understood and wafted out of the hands of the esthetes, his claim will appear modest.)

As much as the wheel is an extension of the foot, the computer is an extension of our nervous system, which exists by virtue of feedback or circuitry.

In *The Myth of the Eternal Return*, Mircea Eliade makes a kind of inventory of the tribal rituals that rehearsed and repeated the process of creation in order that the entire creation should be purged. Nothing could be more antithetic to the mechanical repetitions that begin with Gutenberg and which we still refer to as "scientific proof." In his treatise on *The Senses*, Lowenstein—in describing the structure of nervous reaction incidentally and by implication—explains the spastic condition of society during the centuries of mechanical organization:

Why all social institutions are spastic

Our story is becoming complicated. A further complication arises from the fact that for each muscle moving a limb one way, there is at least one other moving it in the opposite direction. The biceps which flexes our arm is counteracted or antagonized by the triceps, which extends or straightens it. Sherrington worked out the remarkable coordination between such antagonistic pairs of flexor and extensor muscles. They receive on every occasion exactly opposite commands from the command center. When one is made to contract by proprioceptive reflex, its antagonist is

made to relax simultaneously. All movements are smooth and are carried out within the safety limits of the load-bearing capacity of muscles and tendons.

The jerky movements of a spastic patient show how necessary this control mechanism is in such a simple activity as walking. The feedback of information from the muscles is defective in a spastic. One of the routine tests included in a general medical examination is designed to show whether the spinal reflex system is in order.

The wedding of electronics and biology

It is quite fitting that biologists should become interested in automation. In *Robots, Men and Minds,* Ludwig von Bertalanffy devotes a good deal of attention to automation and its relation to biology. He finds that automation and electric technology have made some of their most significant manifestations in the world of symbolism:

The evolution of symbolism, we have said, is the fundamental problem of *anthropogenesis. All* other human achievements are minor or derived from it. For example, language: The bees have a perhaps even more perfect communication system; and there can be no dispute that insect societies work much more perfectly and smoothly than their human counterparts. Or technology, man the *Homo faber.* With few exceptions—the wheel, the cracking of atoms and space flight—nature's technology surpasses that of man—to the extent that the traditional relationship between biology and technology was recently reversed: while mechanistic biology tried to explain organic functions in terms of man-made machines, the young science of bionics instead tries to imitate nature's inventions.

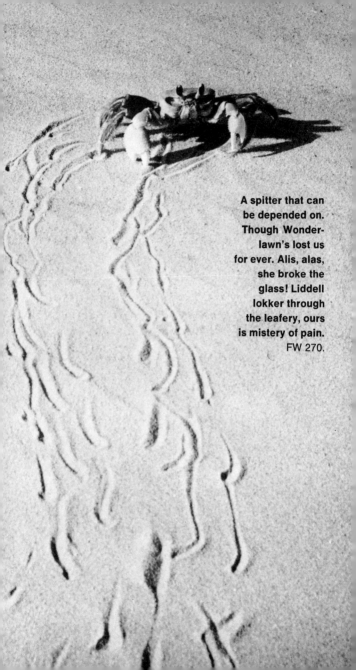

A spitter that can
be depended on.
Though Wonder-
lawn's lost us
for ever. Alis, alas,
she broke the
glass! Liddell
lokker through
the leafery, ours
is mistery of pain.
FW 270.

In the present time he feels it has become obvious that "for evolution of cognitive symbols, apparently some glorified gestalt perception is prerequisite: Insight or seeing things together which were previously unconnected." The ability to do this is very much related to the human power of retracking a path of events or of following a process quite independently of the material that is being processed:

The scientific return to magic

> The *decisive* step seems to be that man, in one way or the other, made an *image* of things apt to be their representative. It is probably not so important whether this was a *graven* image—such as the paleolithic carvings of animals—or an *acoustic* image—the first word of representative language. But it was decisive that man, in some way, *dissociated* something from himself which was to stand in for something else. As the Bible very appropriately says, Adam be-

"I'm going to be a computer when I grow up."

gan his career in Paradise by giving *names* to things and animals—and in this he gained domination over them. There can be hardly a doubt that the origin of symbolism is intimately connected with magic; be it *word magic*—a word gives power over the thing named; or *manipulative magic*—the clay image is the enemy, and he is killed when the image is transfixed with a needle.

Willed without witting, whorled without aimed. FW 272.

(Apropos his allusion to Adam, any Christian might add that whereas the first Adam was an esthete, viewing and naming and enjoying creatures, a resident in a world he never made, the second Adam remade His first establishment and conferred on man totally new powers of creativity such as the first Adam had not known. To the Christian the Incarnation means that all matter was reconstituted at a historical moment and that matter is now capable of quite superhuman manipulation.)

The matter of symbolism raises at once not only words but artifacts and the environments created by artifacts. Technologically-created environments are as symbolic as any metaphor could ever be. "Man's reach must exceed his grasp, or what's a metaphor?" The power to read the language of environments was the province of the seer in primitive societies; he related the languages which he discerned in the outer world to the inner world, keeping both as a divine secret committed to him. The secrets he discovered were great breakthroughs or epiphanies or showing forth of the divine through the environmental veils. In the eighteenth century Giambattista Vico devoted his *Scienza Nuova* to his recovery of what he felt had been a lost science.

Literate rationalistic man had relinquished the power of vision in order to manipulate matter, as it were. Vico is entirely concerned with the invisible environments that the biologist Bertalanffy today calls symbolism. James Joyce devoted his *Finnegans Wake* to implementing Vico.

Thunder, as "explanation," pervades *The Waste Land:* "Datta. Dayadhvam. Damyata." The word for thunder in German is the same as the word "give" in French. Eliot and Joyce were punning in many languages. What has impressed Bertalanffy and many scientists in our times is that:

> In the past twenty years or so, dissatisfaction with the mechanistic attitude has led to a multitude of developments in psychology which are different in content but which agree in the rejection of the robot model of man. Werner's organismic-developmental approach was one of the first and foremost among these trends. Other names and currents come easily to mind: Gordon Allport, the Bühlers, Piaget, Goldstein, Maslow, Schachtel, J. Brunner, the New Look in perception, the emphasis on exploratory behavior and creativity, neo-Freudians such as Rogers and the ego psychologists, Sorokin in sociology, phenomenological and existentialist approaches, and others. The field is large, my time and competence limited; so I again must resort to oversimplification.
>
> I believe that there are certain principles in common in an emerging psychology of man or, as we should rather say, in a new science of man or general anthropology, because this will obviously be an interdisciplinary enterprise including biology, psychiatry, sociology,

linguistics, economics, the arts and other fields.

One of the many implications of this passage is that our new technological resources have simply bypassed the Newtonian age. Such sudden changes amount to a kind of transvaluation of values and a resulting feeling of the meaninglessness of life and human endeavor because of the disappearance of all the previous goals and objectives. In an article called "People and Jobs" John Tebbel in *Saturday Review* (December 30, 1967) comments on the paradox that manpower is in short supply while three million Americans are unemployed:

> While the Negro unemployed have received the most publicity because their frustration and bitterness are the torches which light urban fires, there are other people out of work who have at least a high school education and a recognizable skill. Increasingly today theirs is not a marketable skill, because the job they knew how to do has been eliminated by automation.

Everybody is familiar with the theory that in the new technological society so many new jobs would be created that no unemployment could result. This view overlooks the fact that the new technology, like the new American environment, requires highly sophisticated training. Our whole social life is now becoming a service environment. Tebbel comments:

> There are now so many people in the United States that the task of teaching them, nursing them, feeding, moving, directing, and informing them is rapidly slipping out of control, especially in such critical occupations as those involved in health and education.

Tebbel doesn't mention entertainment as one of the largest service industries, but he does mention radio as an area of increasing sophistication:

> The radio has moved from vacuum tube to transistor to integrated circuit before most of us knew what "solid state" meant. Because of this speed, and concurrent factors, it is becoming more difficult to predict far enough ahead what manpower needs are going to be so that something can be done to influence the makeup of the work force.

He then assigns the major share of the blame on government:

> The nation has been willing to put up with an educational system which is not geared to the new society, just as it supports a horse-and-buggy Congress which only dimly approaches the needs of the space age.

When Mr. Tebbel turns to the Soviet Union, he fails to realize the advantages that a backward country enjoys in the age of automation. They do not have huge nineteenth-century plants or attitudes to scrap. They don't have to transform mechanical and literate minds into electronically oriented workers. The backward country starts with the latest. In the eighteenth century, America was an exceedingly backward country, giving it a great advantage over Europe and England. America could begin with all the latest developments in Europe and England without bothering to metamorphose and adapt to ancient institutions.

The critical anxiety in which all men now exist is very much the result of the interface between a declining mechanical cul-

ture, fragmented and specialist, and a new integral culture that is inclusive, organic, and macroscopic. This new culture does not depend on words at all. Language and dialogue, in fact, have already taken the form of interplay between whole areas of the world.

Can you read this interplanetary message?

But the world, mind, is, was and will be writing its own wrunes for ever, man, on all matters that fall under the ban of our infra-rational senses...
FW 19-20.

The tribal Pavlov naturally regarded the environment as stimuli and never thought of stimulus as control of an environment:

At the beginning of this century the Russian physiologist Pavlov carried out some interesting experiments upon dogs, from which we have learned a great deal about the conditioned reflex. Pavlov performed his experiments in the following fashion. A dog was fed with appetizing food, and at the same time a bright white or colored light was flashed within view of the animal. The light was shown for several days each time the animal was fed. After a certain number of such trials, or lessons as they might be called, the light was shown, but the animal was not fed. Nevertheless a pro-

"The Human Body and Its Functions," by Charles H. Best and Norman B. Taylor. Holt, Rinehart and Winston, Inc.

fuse secretion of saliva occurred. The same remarkable result was obtained when, instead of a light being shown at the time of feeding, a note was sounded upon a horn, or a bell was rung, or the skin was stimulated by a weak electric shock. After the preliminary period of training, the sound of the horn or the bell or the sensation of the electric shock was sufficient alone to cause secretion. We would not think that a dog, however intelligent, could be capable of making a distinction between lights which differed slightly in color, or of distinguishing between musical notes of different pitch. Yet, when a light different in color from that used during the training period was shown at the time of the test, no secretion of saliva occurred. Similarly, a note only slightly higher or lower in pitch than the one employed during training was unable, when tested alone upon the animal, to cause any secretion. It was entirely disregarded.

The nature of the anxiety that now pervades human consciousness had many earlier anticipations. For example, the work of Pavlov, in revealing the fact of conditioned reflexes, had a totally different meaning for the Russian and the European. Pavlov had been unable to condition his dogs in his experiments until he had completely conditioned the laboratory environments in which they lived. Until precise thermal and auditory controls were introduced into the laboratories the conditioning did not occur. The bell did not elicit salivation. To the European it was not the conditioning of the laboratories but the fact of automatic salivation that created the excitement. Indeed, the ordinary psychological effect makes no mention of the laboratory conditioning. The

Westerner lives in a man-made environment, mechanically conditioned and time structured:

> Unreal City,
> Under the brown fog of a winter dawn,
> A crowd flowed over London Bridge, so many,
> I had not thought death had undone so many.
> Sighs, short and infrequent, were exhaled,
> And each man fixed his eyes before his feet.
> Flowed up the hill and down King William Street,
> To where Saint Mary Woolnoth kept the hours
> With a dead sound on the final stroke of nine.

"The Waste Land," from "Collected Poems 1909-1962," by T. S. Eliot. Harcourt, Brace & World, Inc. Faber and Faber Ltd.

In the new electronic environment we end the Pavlovian laboratory of mechanical civilization and are primitive once more.

Living in a man-made environment, extremely specialized and fragmented, the Westerner was as oblivious of his environment as the Russian is oblivious of his tribal environment, which is neither mechanical nor man-made. Western mechanism has not penetrated the Russian psyche, any more than it has the Japanese psyche. Therefore, to the Russian, the exciting event in Pavlov's experiment was not the conditioning of the dogs but of the laboratories. But to the Westerner, the revelation that he was a preconditioned robot, thanks to his own ingenuity and machinations, was a most disagreeable discovery. Accompanying this new awareness of his robot condition, John Dewey and many other psychologists devised new strategies based on no awareness of either the old mechanical environment or the new electric one. The strategy of permissiveness in the upbringing of the young, as opposed to an obedience and discipline that enabled the young to "fit in" to the mechanical world, became a kind of crux for controversy. Permissiveness was expected to enable the youngster to create his own world in the style of a romantic artist instead of fitting into somebody else's world. The distorted paradoxes that ensued have yet to be resolved.

Where flash becomes word and silents selfloud.
FW 267.

In *TV Guide* for January 6–12, 1968, Dr. Haim G. Ginott manages to become entangled in every facet of this old paradox. When he says television should not be used as a threat or a reward, Dr. Ginott is unconsciously acknowledging that television is an environment. To use its use or non-use as reward or punishment is as meaningless as saying to a child that

he will be allowed to have access to air or not. It is like saying that he will have to live in a non-heated part of the house, whereas if he is obedient he can share the heated portions of the house. Television, the heliotrope, has nothing in common with the movies in this respect. The movies are no more environmental than a story book but a phantom city, phaked of philim pholk. The children in Watts (Calif.) were quite right in asking, "Why should we go to school only to interrupt our education?" Television is not a credit course in anything, but it very definitely has the marks of a natural environment in which the child forages and finds his way as much as any Indian ever did in the out-of-doors.

Pavlov was the man who tipped us off that our old mechanical environment and its consequences were yielding to a totally new environment created by an antithetic

technology. His discovery about conditioning is quite trivial since all Western men have experienced this for centuries. The portentous discovery he made was that any controlled environment, any man-made environment, is a conditioner that creates non-perceptive somnambulists. The fact that a natural or non-controlled environment has quite different effects upon human perception has long agitated the anthropological world. Anthropologists have been led to study the patterns of culture of native societies and the wonderful results of native environments in shaping native institutions, without any corresponding increase of insight into their own culture. However, they have been prolific in denunciations.

A U.S. educator says Indians have a happier way of getting along with people than white men and do not experience the loneliness that often accompanies success in white society.

The Canadian Press.

According to Rev. John Bryde, superintendent of Holy Rosary Mission School, Pine Ridge, N.D., "the Indian works as a group. His motivation is to do something for the group."

Dr. Bryde, preparing a course of studies for Indian schools in the United States, said the Indian has a better set of values than the white man.

"The fact that he has existed for over 20,000 years would indicate he's got a good sense of values," he said.

Dr. Bryde told the Alberta Indian Education Association on Wednesday that "as to teaching Indians about human living, we can teach them nothing and they can teach us everything."

He said that when an Indian looks at a man he wonders if that person is kind, good, generous and wise, and these values are in direct conflict with the materialistic orientation of white society.

The course of Indian studies, to be introduced in U.S. schools next year, stresses Indian history and reminds Indians that their value system is probably better than white values.

The Indian is hurt, he said, when white society rejects him, "but really he couldn't care less what you think about him because he is convinced that his value system is better and that what is important to him is not important to you."

He said Indians will always have to have reserves because "an Indian feels a mystical relationship to the land. It's part of his source of identity." He suggested industry could be moved on to reserves.

Dr. Bryde said he felt the Indian gets a fair deal in the "tremendous financial support" he gets from white society, but "he would also like to get the understanding of the non-Indian world, to understand him as an Indian."

A headline in *The New York Times* for January 10, 1968, read: THE DRUG

SCENE: A GROWING NUMBER OF AMER-
ICA'S ELITE ARE QUIETLY TURNING ON.
It is not uncommon for people on these
trips, especially with new chemical drugs,
as opposed to organic ones, to develop
the illusion that they are themselves com-
puters. Similarly, where once psychotic
children identified themselves as bunnies
and cats and other beasts from the fun
animal world, now they identify with cars
and television sets.

This, of course, is not so much a hallucina-
tion as a discovery. The computer is a
more sophisticated extension of the cen-
tral nervous system than ordinary electric
relays and circuits. When people live in
an environment of such circuitry and feed-
back, carrying much greater quantities of
information than any previous social
scene, they develop something akin to
what medical men call "referred pain."
The impulse to get "turned on" is a simple
Pavlovian reflex felt by human beings in
an environment of electric information.
Such an environment is itself a phenome-
non of self-amputation. Every new tech-
nological innovation is a literal amputa-
tion of ourselves in order that it may be
amplified and manipulated for social
power and action. Naturally, such ampu-
tation is associated with pain that is re-
ferred not so much to the body as to brain
centers. As Lowenstein points out: "There
is hardly a brain center outside the reach
of pain pathways." Most people are in the
habit of associating technical innovations
with the physical upset to their customary
routines and their customers. This is surely
a very small aspect of the case, and Low-
enstein deserves to be quoted at some
length:

Many valuable data are collected by surgeons in their often desperate attempts to stop overpowering pain by sectioning of this or that nervous pathway connected with diseased organs. This is a slow and haphazard process, and our relative lack of information is due to the fact that a suffering man is the only reliable source of information on pain. Alas, this information can be very misleading. A patient suffering from severe phantom pain can only point in the direction of a long-lost limb to indicate its origin, and the intriguing phenomena of referred pain can add to the confusion. Referred pain often arises from impulses in one deep-seated organ, but is localized by the sufferer somewhere at the surface of the body. A lot of backache and many types of headache fall within this category of pain. One explanation why we should think we have a pain somewhere in the skin, when the source of trouble may be the appendix, the heart or the womb, is that pathways from these organs have no direct connection with the brain but relay on to the same neuron as pain fibres from the skin. Consequently, a stream of impulses from the diseased organ is interpreted by the sufferer as coming from the areas of skin connected with this relay station. Physicians use maps of the body surface showing certain common targets of referred pain, and a tenderness of the skin in a certain place can be a useful guide to the real spot of trouble.

Spickspook-spokesman of our spec-turesque silen-tiousness!
FW 427.

The fact that pain is a sensation that "can even survive the disappearance of the initial source" is of the utmost significance to the student of media. This fact points to the central nervous system itself as a key factor in pain, and helps to ex-

plain why institutions and technologies which have long been amputated from the social scene can continue to inflict corporate misery.

With the putting of the central nervous system into the environmental role which has occurred in recent decades, human sensibilities have undergone a total revolution. Two centuries of mechanical environment had abrased and aborted nearly all human motivation, inspiring a lust for violence as a compensatory feedback. All that is now changing. The world of electric circuitry that is now the normal environment inspires quite opposite responses. In *The New York Times* article cited earlier, there is the case of the retailer in Charlotte, North Carolina. He is a Southern-born Republican who took five LSD trips: "I learned from LSD the beauty of life—that it's too precious, so that we must not kill unless we are being invaded. I don't want my son to kill, in Vietnam or anywhere." He added: "I would have been proud of my son if he had torn up his draft card and not gone into the army, but he was too square."

Television kills telephony in brothers' broil. Our eyes demand their turn. Let them be seen! FW 52.

The extreme and pervasive tactility of the new electric environment results from a mesh of pervasive energy that penetrates

our nervous system incessantly. The sense of touch had been anesthetized in the mechanical age, but today television is only one of the tactile agents transforming popular awareness. Of course, color TV is very much more tactile than black and white TV. Tactility is the integral sense, the one that brings all the others into relation. This sense is greatly enhanced by the polarized and feedback pattern of our new electric environment. This environment itself constitutes an inner trip, collectively, without benefit of drugs. The impulse to use hallucinogens is a kind of empathy with the electric environment, but it is also a way of repudiating the old mechanical world. In *The Times* article one of the people interviewed was a lawyer who said he regularly used marijuana and LSD:

> After my first trip, it was unmistakably clear to me that this was not what my life was about—real estate law. Other people, probably stronger people, could come to this conclusion without drugs. I couldn't. Suddenly I didn't feel that I was put upon this earth to reduce landlords' real estate taxes.

One psychologist pointed out that these drugs provide a sort of esthetic headstart for artistically deprived adults: "The adult will gain new insights through the use of hallucinogens. They may also stimulate a new-found interest in music, art and nature." The arts are primarily the world of audio-tactile, even in painting. These drugs, which simulate more intensely our new electric environment, therefore enhance these senses that have long been neutralized by the merely visual culture of the mechanical age.

And for the honour of Alcohol drop that you-know-what-I've-come-about-I-saw-your-act air! FW 255.

The Times article cites the case of a painter who "uses laughing gas when he can get it 'because, man, it really makes you zoom off into space.' "

Perhaps the most lavish and extensive effect of the drugs has been to raise sexuality on an everyday basis to levels that render D. H. Lawrence quite obsolete. "When my husband first took LSD, he got very sensual; he kept wanting to touch me. Everytime I take a trip with him or with friends I provide good wine, good cheese, good incense—everything to stimulate our senses into whatever avenue we want them to go."

The Times series is characteristic rearview mirrorism. It looks at the drug scene as if De Quincey and Poe and Baudelaire had extended their "decadence" to the entire American scene. The fact is that getting "turned on" is only very incidentally

chemical and is on an overwhelming scale a fact of electric engineering. All the backward countries in the global village are as much turned on by the electric environment as the American Negro or the teen-agers of the Western world. The elders of the literate societies don't easily turn on because their sensibilities have hardened in a visual mold. But pre-literates and semi-literates and the non-literates of our own society not only "turn on" but they also turn against the older literate and mechanical culture. The American Negro who has long coexisted with this literate culture especially feels anger when he gets "turned on," because he can see that the causes of his degradation are to be found in a technology that is now repudiated by his masters. When the electric age began to be felt during and after the First World War, the world of Negro jazz welled up to conquer the white. Jazz was

a Negro product because it is directly related to speech rhythms rather than to any printed page or score. Primitive, tactile art and kinetically charged rhythms in music and painting alike are the normal modes of any non-literate world. They have now become the central mode of our latest technology. This new electric technology, like any other innovation, affords a mirror in which we see the old technologies with ever increasing clarity.

(There extand by now one thousand and one stories, all told, of the same). FW 5.

The New York Times on January 11, 1968, heads its article on hallucinogens MANY STUDENTS NOW REGARD MARIJUANA AS A PART OF GROWING UP. One of the pervasive themes of *The Times'* five-part series on the use and abuse of drugs in the United States is the highly tribal and group-oriented character of the drug-users. Drug taking, which is today inspired by the penetrating information environment with its feedback mechanism of the inner trip, is as involving as the electric world itself.

The dweller in the old mechanical world lived on dreams as a way of contacting the fuller world. The whole nineteenth century in a sense ended with the movies and manifested its preference for a dream world as altogether richer than real life. The workaday world was not only ugly but fragmented and specialized so that private dreaming of a better life occupied a good deal of time and energy. The opposite is the case in our electric time. It is an age of involvement and a multitude of service environments which link people at many levels: "The frightening thing about these kids is that they'll take anything, anywhere," said a young medical student at Yale, who is studying drug usage. "I used to think it wasn't so much different from what we did at that age, but this is really dangerous." Indeed, it is the teenyboppers' ready acceptance of drugs such as methedrine, which can induce psychological dependence, compulsive, sometimes violent behavior, and intense feelings of paranoia, which hastened the break-up of the Haight-Ashbury hippie community in San Francisco. The high school student most likely to use drugs, according to several high school principals, deans and suburban psychiatrists, is the bright student, who does not participate in school activities, who often has a troubled home life and who feels alienated.

The absurdity of regarding such developments as "one of those things" is no greater than that found in the business world which imagines that it can introduce vast innovations without any ensuing consequences. "The consequences of the images will be the images of the conse-

...realising on fundamental liberal principles the supreme importance, nexally and noxally, of physical life... FW 35.

Can you rede (since We and Thou had it out already) its world? It is the same told of all. Many. Miscegenations on miscegenations. FW 18.

quences." That is to say that the psychic and social impact of new technologies and their resulting environment will reverse all the characteristic psychic and social consequences of the old technology and its environments. As Bertalanffy puts it:

> In somewhat different terms, the algorithmic system becomes a calculating machine, as conversely every calculating machine is materialization of an algorithm. Suitable data being fed in, the machine runs according to pre-established rules and eventually a result drops out which was unforeseeable to the individual mind with its limited capacities.

The clash of old and new environments is anarchic and nihilistic today. For example, what is called the "Death of God" is the transition from Newtonian to Einsteinian imagery, the cosmic clockmaker having become a transistor in popular imagination. *The New York Times* quotes Dr. H. M. Kormos: "One gets from these kids a feeling of nothingness, of pervasive depression... there is a very genuine feeling that life has little to offer, and they speak continually of the dreariness, the drabness of everyday life."

Just as the Japanese insist that it is not the tea but the ritual that gives meaning, Dr. Kormos suggested that it is the procedure of group participation and sharing of the drug that lends "a sense of belonging and identity that may be more important to the student than the effect of the drug."

In *The Times* series, a female entertainer is quoted as saying:

I get done with a performance in New York and I have a television show to tape on the Coast the next morning. If I don't sleep on the plane I'm finished. The barbiturates give me the sleep; the amphetamines keep me going. In the old days I'd go on the 20th Century Limited, read a book, sleep and relax on the way to Hollywood. Now you can't.

As a sort of capsule observation, it could be said that the computer is the LSD of the business world, transforming its outlook and objectives. None of the existing goals of twentieth-century business enterprise can survive the impact of the computer for even ten years. The drop-out is not a phenomenon limited to the high school or the campus, for the higher the executive the more he feels cut off from the real developments of the operation he directs.

A nineteenth-century voice from the deeps of the "dismal science" attempts a different note (John Galbraith in *The New Industrial State*):

> The Industrial System identifies itself with the goals of society. And it adapts these to its needs. The adaptation would not be so successful were those who comprise society aware of it—did they know, in effect, how they are guided. It is the genius of the industrial system that it makes the goals that reflect its needs—efficient production of goods, a steady expansion in their output, a steady expansion in their consumption, a powerful preference for goods over leisure, an unqualified commitment to technological change, autonomy for the technostructure, an adequate supply of trained and educated manpower—co-ordinate with social virtue and human

... an ex-private secretary of no fixed abode (locally known as Mildew Lisa), who had passed several nights, funnish enough, in a doorway under the blankets of homelessness... FW 40.

The top exec as drop-out or casualty of electric speed-up

"The New Industrial State," by John Kenneth Galbraith. Houghton Mifflin Co.

enlightenment. These goals are not thought to be derived from our environment. They are assumed to be original with human personality. To believe this is to hold a sensibly material view of mankind. To question it is to risk a reputation for eccentricity or asceticism.

Prime Minister Pearson of Canada resigned in 1967 and a sense of having outlived their own uselessness haunts many of the leaders of church and state. In early 1968 there were said to be more than four-hundred vacancies in college presidencies in the United States. It will soon be impossible to entice any reasonably awake person to accept any high political or business position, for the echelons of the old organization chart are beginning to look as meaningless and starved as the calculations of a medieval astrologer. A headline on page one of *The New York Times* for January 11, 1968, read: 200 U.S. BISHOPS WARN ON THREATS TO CATHOLIC UNITY. COLLECTIVE PASTORAL ASSAILS MEN LEAVING PRIESTHOOD AND "HOSTILE" ATTITUDES. The pattern is the same as the ones that have appeared in the LSD sector and in the computer area. Much greater efforts have been made, both in ecumenism and in liturgical reform, to accommodate the new impulse to involvement on the part of both priesthood and laity; but as in any of the other operations of the Western world the patterns of parish and ecclesiastical organization are riddled with the old mechanical forms of specialism and delegation of responsibility and authority. The gesture of Cardinal Léger in stepping down from the cardinalate may be unique in the history of the Church. On December 12, 1967, he

... back to back, buck to bucker, on their airish chaunting car, beheld with intouristing anterestedness the clad pursue the bare, the bare the green ...
FW 55.

left to spend his life with the afflicted in a Japanese leper colony. The apostolate of pain is new in our time; but pain is a language in depth that transcends all linguistic and cultural barriers and is indeed a force of macroscopic gesticulation.

There was possibly a time when show biz was a bigger business than education. Today, education is not only by far the biggest business in the world, it is also becoming show biz.

Wires hummed. Peacefully general astonishment assisted by regrettitude had put a term till his existence:...
FW 98.

... with a vitaltone speaker, capable of capturing skybuddies, harbour craft emittences, key clickings, vaticum cleaners, due to woman formed mobile or man made static and bawling the whowle hamshack and wobble down in an eliminium sounds pound so as to serve him up a melegoturny marygo-raumd, ...
FW 309.

Before departing from the global village for these new themes, let us meditate on the headline about President Johnson as the new Magellan. In our all-at-once little world the governing of the United States permits the highest political business to be transacted beside the singing boards of Easter Island or on an ice floe in the Arctic. In *The Artillery of the Press,* James Reston explains this a little further:

The President's influence is increasing in other ways. Modern communications extend the reach and influence of reporters everywhere, but not so much as they expand the power of the President. The jet airplane has transformed diplomacy. On an hour's notice the President can decide that he wishes to be his own principal negotiator in a foreign land. Immediately, mobile radio transmitters, with all their modern contrivances for scrambling secret Presidential communications, are dispatched to the country concerned. The President's limousine, his teleprompters, even his special chair are loaded into flying boxcars and put down in a few hours in the capital concerned. We may report the news, but he makes it. If Senators are dominating the front pages with their protests against his foreign policy, and professors and editors are creating newsworthy disturbances on the university campuses and on the editorial pages, the President has a convenient remedy. He can divert public attention to himself. He can arrange a conference on an island in the Pacific, for example. Within seventy-two hours, he can bring the leaders of the nations on his side to a meeting that will arrest the interest of the world. Reporters and photographers will converge from all the capitals and

"The Artillery of the Press," by James Reston. Harper & Row, 1967.

Not olderwise Inn the
days of the Bygning
would our Traveller
remote,...from
van Demon's Land,
...lift wearywilly his
slowcut snobsic eyes
to the semisigns
of his zooteac...
FW 56.

Believe me if all those endearing young charms — which I computerized so quickly today.

fill the front pages with accounts of the proceedings, thereby overwhelming the less dramatic Senatorial mutterings.

Let us take a look at the computer in this light and observe how we typically mistake its character as a way of soothing our exacerbated nerves. We read frequent business leaders' announcements: BUSINESS INVESTING MORE HEAVILY IN COMPUTERS TO CUT COSTS and that "computers represent one of the fastest growing capital goods industries, and in spite of the uncertainty with which business heads into the new year, most computer manufacturers are looking for dollar volume growth in the range of 15% to 50%." Statements such as these are naïve in the extreme since the computer absolutely guarantees the elimination of all the businesses that it is now being brought to serve. The extreme decentralizing power of the computer in eliminating cities and all concentrations of population whatever is as nothing compared to its power to translate hardware into software and capital goods into in-

formation. It is well to remind ourselves that the computer made possible the satellite, which ended nature in the sense that it has been understood during the past three thousand years. What we now call the business world is as incompatible with the computer as the military establishment or the motor car industry. The dense information environment created by the computer is at present still concealed from it by a complex screen or mosaic quilt of antiquated activities that are now advertised as the new field for the computer.

It may be simplest to say at once that the real use of the computer is not to reduce staff or costs, or to speed up or smooth out anything that has been going on. Its true function is to program and orchestrate terrestrial and galactic environments and energies in a harmonious way. For centuries the lack of symmetry and proportion in all these areas has created a sort of universal spastic condition for lack of inter-relation among them.

In merely terrestrial terms, programming the environment means, first of all, a kind of console for global thermostats to pattern all sensory life in a way conducive to comfort and happiness. Till now, only the artist has been permitted the opportunity to do this in the most puny fashion. The mass media, so-called, have offered new materials for the artist, but the understanding has been lacking. The computer abolishes the human past by making it entirely present. It makes natural and necessary a dialogue among cultures which is as intimate as private speech, yet dispensing entirely with speech. While be-

moaning the decline of literacy and the obsolescence of the book, the literati have typically ignored the imminence of the decline in speech itself. The individual word, as a store of information and feeling, is already yielding to macroscopic gesticulation.

In *The Codebreakers,* David Kahn raises a familiar statistic: "It has been said that 90 per cent of all the scientists who ever lived are living today." Mr. Kahn continues:

> The remark applies to cryptology with even greater force. The age is one of

"The Codebreakers," by David Kahn. The Macmillan Company, Weidenfeld & Nicolson Ltd. Copyright © 1967 by David Kahn.

... denary, danery, donnery, domm, who, entiringly as he continues highly-fictional, tumulous under his chthonic exterior but plain Mr Tumulty in muftilife ... FW 261.

communications and of Cold War. The titans that confront one another in Berlin and Vietnam and outer space owe much of their effectiveness as superpowers to the vast webs of communications through which they receive information and transmit commands. These networks, more extensive and more heavily used than any in history, furnish cryptologists with unparalleled opportunities. The Cold War gives them the impetus to exploit these opportunities —a stimulus that, in view of the dangers of national extinction, becomes almost an imperative. These two factors converge to produce more cryptology and more cryptologists than ever before.

(Stoop) if you are abced-minded, ... in this allaphbed!
FW 18.

It is ironic that the cryptologists working entirely within the confines of Gutenberg technology have had no clue or inkling of the sorts of new environments that they have created. They think of themselves as merely working inside an older culture, much as the computer engineers think of themselves contained within a machine culture. It is the difference between matching and making, as E. H. Gombrich explains in *Art and Illusion.*

From the beginnings of literacy until now, art has mostly been thought of as representation, a kind of matching of inner and outer environments. Primitive man and post-literate man agree that art is making and that it affects the universe. Mr. Kahn takes several occasions to observe that Chinese and Japanese ideograms do not lend themselves to what he calls cryptology, since they are not fragmented as signs or signals like our alphabet. Thus, in an attempt to match our secret codes, the Japanese invented what they called the "Alphabetical Typewriter '97, the '97

an abbreviation of the year 2597 of the Japanese calendar, which corresponds to 1937." Those few words are themselves a cryptograph or formula for the Westernizing of the whole Orient. It could only be done by fragmentation such as alphabet and typewriter permit. Their own written characters are complex gestalts such as are now forced upon us by the computer. The Orientalization of the Western world is a mere footnote to the electrical supplanting of fragmentation as a technology for coping with nature. A glance at some of the current activities of the computer may be relevant here:

- —Detecting the influence of one poet on the works of another
- —Synchronizing work flow among tens of thousands of people and machines involved in building the supersonic transport
- —Piecing together the clues to a crime
- —Plotting the most efficient route for a milkman
- —Analyzing the vocabulary of eighteenth century French political writers
- —Keeping track of National Bridge Club standings
- —Predicting the best apple-picking time
- —Deciphering ancient languages
- —Identifying a fashion trend in time to capitalize on it
- —Studying flight path of the whooping crane
- —Analyzing molecular structures and English syntax
- —Pinpointing the exact position of the moon at any time in the next two centuries

...take your mut for a first beginning, big to bog, back to bach. FW 287.

The Department of Information at International Business Machines issues a collection of newsclips each month that keeps up with the new computer uses. Some of its late 1967 descriptions of computer activities included such uses as these:

—New management and labor relationships
—A speedup that makes planning mandatory
—As an anti-crime weapon
—As dealing with many problems simultaneously
—As diagnostician, doctor and druggist
—As Cupid, searching the files for ideal matches
—As marriage monitor and arbiter
—As substitute for salesman
—As immigration counselor
—As promoter of executive drop-outs
—As a misunderstood teen-ager
—As encyclopedic legal counsel
—As the nemesis of the bookie
—As ad man
—As highway designer
—As management counsultant

Some of the headlines in a single issue of *Newsclips* (September 28, 1966) were: AVIATION LEADS INEVITABLY TO COMPUTERS, STUDENTS ENTER COMPUTER AGE (REVOLUTION OF THE LEARNING PROCESS), COMPUTERS PUT SPEED INTO THE LAW, COMPUTER GIVES FEDERAL AGENCIES MORE MUSCLE, NEW COMPUTER CONTROL FOR PAPER MACHINE IN SWEDEN, COMPUTER IS KNOCKING AT THE SCHOOL HOUSE DOOR, COMPUTER OFFERS NEW CONCEPT OF INTELLIGENCE, COMPUTER

. . . it's the muddest thick that was ever heard dump since Eggsmather got smothered in the plap of the pfan. FW 296.

AND THE DECENTRALIZATION OF KNOWLEDGE, POLITICAL PARTIES CONSIDER COMPUTER TO SPEED LEADERSHIP BALLOTING.

95

As this huge new limb reaches out into the community, it is inevitable that it will proliferate spastic behavior for some time to come. Lowenstein provides some relevant observations in this matter: "The jerky movements of a spastic patient show ... in such a simple activity as walking. The feedback of information from the muscles is defective in a spastic." The attempt to adapt the new computer to the diversity of older technologies creates a great deficiency of feedback. Lowenstein comments directly on this in relation to automation: "Automatic control mechanisms, especially when they are very critically set and highly sensitive, are liable to oscillate quite violently at times between correction, over-correction, counter-correction, and so on. The engineer calls this 'hunting.'" The ordinary person would tend to call it research and adaptation. So far as the computer is concerned, it is very much at this stage.

In America's first peacetime draft, in 1940, Secretary of War Henry L. Stimson — blindfolded — pulls first number, 158, as America prepares to send her men into World War II.

War as Education:

The subject of pain as the natural accompaniment of innovation leads naturally into this section. It concerns war as education.

When one has been hurt by new technology, when the private person or the corporate body finds its entire identity endangered by physical or psychic change, it lashes back in a fury of self-defense.

Who gave you that numb?
FW 546.

When our identity is in danger, we feel certain that we have a mandate for war. The old image must be recovered at any cost. But, as in the case of "referred pain," the symptom against which we lash out may quite likely be caused by something about which we know nothing. These hidden factors are the invisible environments created by technological innovation.

Nobody, for example, is happy about the decline of the West or its rapid Orientalization. Spengler devoted two stout tomes of romantic description to this theme without offering a single clue as to the causes of change. In *Life* magazine, Charles A. Lindbergh expresses his disillusionment with Western man and his mechanical technology, saying that if he were to have a choice, he would settle for the life of nature. Fifty years before Lindbergh, Yeats, Eliot, Lewis, Pound, and many other artists explained in detail how, as the Western mechanical world reached the limits of its potential, all of its characteristic modes and functions reversed their characteristics. The frantic effort of the literate and mechanical powers to retain

"Well, it is a little exaggerated. We're applying an $18,000,000-solution to a $2-problem. But, still, one of the little mothers *was* firing at us."
—U.S. pilot in Vietnam.

Every new technology necessitates a new war

their mechanical ascendancy while being undermined from within by the integral and organic character of electric technology creates the typical confusion of the present day.

What is to be the political and social impact of radio and television technology on peoples who have had neither book nor press? So far as radio is concerned, the answer is given by Frantz Fanon in his *Studies in a Dying Colonialism:*

> Since 1956 the purchase of a radio in Algeria has meant, not the adoption of a modern technique for getting news, but the obtaining of access to the only means of entering into communication with the Revolution, of living with it. In the special case of the portable battery set, an improved form of the standard receiver operating on current, the specialist in technical changes in underdeveloped countries might see a sign of a radical mutation. The Algerian, in fact, gives the impression of finding short cuts and of achieving the most modern forms of new-communication without passing through the intermediary stages. In reality, we have seen that this "progress" is to be explained by the absence of electric current in the Algerian *douars.*

> The French authorities did not immediately realize the exceptional importance of this change in attitude of the Algerian people with regard to the radio. Traditional resistances broke down and one could see in a *douar* groups of families in which fathers, mothers, daughters, elbow to elbow, would scrutinize the radio dial, waiting for the

"Studies in a Dying Colonialism," by Frantz Fanon. Monthly Review Press.

All human progress is a result
of standing on the shoulders
of our predecessors.

Voice of Algeria. Suddenly indifferent to the sterile, archaic modesty and antique social arrangements devoid of brotherhood, the Algerian family discovered itself to be immune to the off-color jokes and the libidinous references that the announcer occasionally let drop.

Almost magically—but we have seen the rapid and dialectical progression of the new national requirements—the technical instrument of the radio receiver lost its identity as an enemy object. The radio set was no longer a part of the occupier's arsenal of cultural oppression. In making of the radio a primary means of resisting the increasingly overwhelming psychological and military pressures of the occupant, Algerian society made an autonomous decision to embrace the new technique and thus tune itself in on the new signaling systems brought into being by the Revolution.

The Voice of Fighting Algeria was to be of capital importance in consolidating and unifying the people...the use of the Arab, Kabyle and French languages which, as colonialism was obliged to recognize, was the expression of a nonracial conception, had the advantage of developing and of strengthening the unity of the people, of making the fighting Djurdjura area real for the Algerian patriots of Batna or of Nemours.

Before launching into the more complicated aspects of war as education, a few notes on Napoleon as educator may be relevant.

The aspect of war as education appears in any life of Napoleon. Quite early in

his large monograph, J. Holland Rose comments:

> In the personality of Napoleon nothing is more remarkable than the combination of gifts which in most natures are mutually exclusive; his instincts were both political and military; his survey of a land took in not only the geographical environment but also the material welfare of the people. Facts, which his foes ignored, offered a firm fulcrum for the leverage of his will: and their political edifice or their military policy crumbled to ruin under an assault planned with consummate skill and pressed home with relentless force.

"The Life of Napoleon I," by J. Holland Rose. G. Bell & Sons, Ltd.

For the training of his recruits, Napoleon was in the habit of placing long lines of planks on his parade ground in order to teach his clodhoppers and yokels how to march in straight lines. Julius Caesar probably had similar gimmicks at his disposal. Perhaps Napoleon felt a certain sympathy for the semi-literate, since he was semi-literate himself. He was unable to spell or write correctly in any language. His culture, like that of Alexander the Great, was totally unacceptable to the establishment. Alexander was representative of the Macedonian world which was still tribal, like the current Russian world. The advanced culture of the city states had only tinged this tribal territory and some historians consider that it was this factor that enabled Alexander to transcend the limitations of these exclusive city states and to think in terms of a cosmopolitan world federalism. These are matters directly related to phonetic literacy and its effects on politics and social life.

In addition, Napoleon tied their legs together so that they could step only eighteen inches at a time

Jehosophat, what doom

ere! FW 255.

Alexander was a drop-out from Aristotle's university

Napoleon had very much the same tribal background as Alexander, but it was one tinged by the European eighteenth century. For example, Napoleon was enthusiastic about Rousseau, who taught a primitive tribalism as a basis for human unity and happiness. Like many a semiliterate, Napoleon was prolific in inventions. His semaphore telegraph carried messages from Rome to Paris in four hours, giving him a huge advantage over his enemies. Perhaps most extraordinary of all was his insistence in the interest of speed that everybody keep to the right-hand side of the road in order to expedite and simplify traffic problems. Where his armies went, right-hand driving has remained, even in Russia. He never got to Sweden, and the Swedes didn't switch to the right-hand side until 1967. He never got to England, and they still drive on the left-hand side. But even in Napoleon's day, the English had probably developed too big a stake in their own way of driving to make any transition possible.

To speed his armies, Napoleon made all his countries drive on the right-hand side of the road

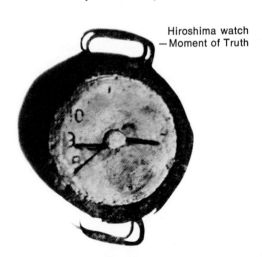

Hiroshima watch
—Moment of Truth

"...space we can recover, time never;...

I may lose a battle, but I shall never lose a minute..."

This insistence on rapid movement as a basic principle of war highlights another of Napoleon's master concepts—the vital significance of time and its accurate calculation in relation to space. "The loss of time is irreparable in war," he once asserted. Considerations of time and distance were the basic calculations underlying all his great strategic moves. "Strategy is the art of making use of time and space. I am less chary of the latter than of the former; space we can recover, time never"; "I may lose a battle, but I shall never lose a minute"; "Time is the great element between weight and force." *The Correspondence* is full of references to this element of warfare as understood by Napoleon. Hours, even days, could be saved or gained by a careful selection of the best routes to the chosen objective. Indeed, Napoleon did not usually demand an unreasonable degree of effort from his marching columns—except, as we have seen, at

"The Campaigns of Napoleon," by David G. Chandler. Copyright © David G. Chandler 1964. The Macmillan Company, Weidenfeld & Nicolson, Ltd.

moments of crisis; under more or less normal conditions he expected them to cover only an average of between 10 and 12 miles a day. For the real secret of his rapid concentrations and unanticipated *blitzkrieg* blows lay far more in the selection of the shortest and most practicable routes to preselected points than in inspiring his men to continue their superhuman efforts. This type of true economy of effort eased the wear and tear on the troops, reducing the wastage occasioned by sickness and desertion, and ideally left a margin of time each day for dealing with any unforeseen incidents or implementing any change of plan.

In the matter of artillery and the deployment of force, Napoleon was entirely a child of his industrial time with its new specialization and concentration on single effects and single products:

One of the best known sayings of Napoleon is the following: "The principles of war are the same as those of a siege. Fire must be concentrated *on a single point* [italics added] and as soon as the breach is made the equilibrium is broken and the rest is nothing." As Captain B. H. Liddell-Hart has pointed out, subsequent military commentators have seized upon the phrase "a single point" and largely ignored the really vital word "equilibrium" toward the end of the sentence, which undoubtedly holds the real lesson which the Emperor was trying to convey. It is by upsetting the enemy's "balance" that the victory is won; the concentration of fire and the opening of a breach are only the means to the true end—which is the psychological destruction of the enemy's will to continue resistance. Nor is this the only misunderstanding occa-

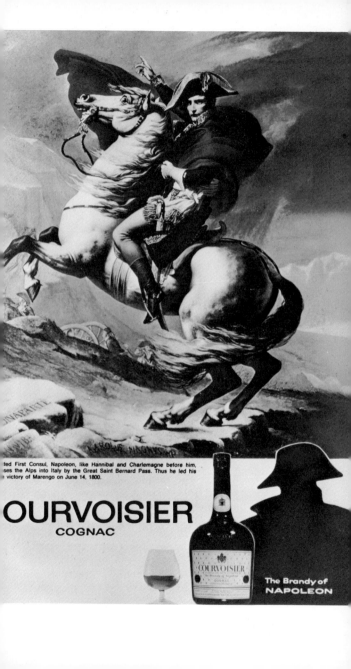

ted First Consul, Napoleon, like Hannibal and Charlemagne before him,
ses the Alps into Italy by the Great Saint Bernard Pass. Thus he led his
 victory of Marengo on June 14, 1800.

OURVOISIER

COGNAC

The Brandy of
NAPOLEON

sioned by this single observation. Controversy has also raged around the word "point," one school maintaining that Napoleon meant the strongest sector of the enemy line, another that he implied the weakest. However, a study of the actual campaign [Piedmont, 1794], which occasioned Napoleon's observation, suggests that he might well have used the word "hinge" or "joint" in place of the word "point"; thus a small matter like the careless choice of a single word can lead to immense argument and misrepresentation. Many ideas have been attributed to Napoleon which he would be the first to refute.

Napoleon's dream of a continental system makes him father of the European Common Market

The limitations of vision occasioned by the new industrial technology not only affected Napoleon's military but his economic outlook. His idea of a "continental system" has at last come home to roost in the European Common Market. Like our space program, it is more than a century out of date. Nothing, however, could better illustrate the union of military and economic and educational concepts than Napoleon's involvement in the social and economic theories of his time. In his *The Life of Napoleon I,* Rose says:

> Among the many misconceptions of the French revolutionists none was more insidious than the notion that the wealth and power of the British people rested on an artificial basis. This mistaken belief in England's weakness arose out of the doctrine taught by the *Economistes* or *Physiocrates* in the latter half of the 18th century, that commerce was not of itself productive of wealth, since it only promoted the distribution of the products of the earth; but that agriculture was the sole source of true wealth

and prosperity. They therefore exalted agriculture at the expense of commerce and manufactures, and the course of the Revolution, which turned largely on agrarian questions, tended in the same direction. Robespierre and St. Just were never weary of contrasting the virtues of a simple pastoral life with the corruptions and weakness engendered by foreign commerce; and when, early in 1793, Jacobinical zeal embroiled the young Republic with England, the orators of the Convention confidently prophesized the downfall of the modern Carthage. Kersaint declared that "the credit of England rests upon fictitious wealth:... bounded in territory, the public future of England is found almost wholly in its bank, and this edifice is entirely supported by naval commerce. It is easy to cripple this commerce, and especially so for a power like France, which stands alone on her own riches."

Today, Nyerere in Tanzania governs by helicopter and radio for lack of rails and roads. He offers an excellent example of how backwardness makes it easy to use the latest technology. However, he is himself an agrarian who wishes to use the latest technology to confirm the principle of decentralism which is essential to it. His industrialists, on the other hand, are committed to the older pattern of centralism and mechanical specialism. In due time, a civil war could ensue over the clash of these technologies. Such was the case in the American civil war where the imbalance of an agrarian economy on one hand and a mechanical one on the other not only led to a great conflict of interest, but (as Galbraith says, in *The New Industrial State)* "delayed the abolition of slavery by several years." An agrarian society

One feared for his days. Did there yawn? 'Twas his stommick. Eruct? The libber. A gush? From his visuals. Pung? Delivver him, orelode ! He had laid violent hands on himself, it was brought in Fugger's Newsletter...
FW 97.

... what all where was your like to lay the cable...
FW 25.

The Civil
War delayed
the abolition
of slavery

does not have goals or objectives or specialized techniques of production. An electric society has the same tendency as the agrarian one since it swiftly translates hardware into software or information. The information approaches the condition of speech and more and more becomes capable of being learned by a child. The following comment of Galbraith helps to focus war as education on the one hand and the related problem of violence and identity on the other hand:

> The problem of goals begins with the relation of the individual to organization, in this case to the technostructure. What an organization will seek from society will be a reflection of what members seek from the organization. If soldiers serve only for pay, the army is not likely to concern itself deeply in politics—at least so long as the pay is forthcoming. But if, as with Cromwell's men, they serve with a view to the salvation of their souls, they are unlikely long to be politically neutral, at least in a wicked country. Legislatures will do well to keep their doors locked. If, as in Latin America, men join the Army less from an excess of martial valor than from a minimum of political ambition, the danger will be even greater. If men principally want money from a corporation, the corporation will be primarily concerned with extracting money from the society. If they are interested in economic security or personal prestige, the corporation can hardly fail to reflect this in the kind of business it conducts.

"The New Industrial State," by John Kenneth Galbraith. Houghton Mifflin Co.

With acknowledgment of our fervour of the first instant he remains years most fainfully. For postscrapt see spoils. FW 124.

"A good joke is worth a thousand words."
—Pat Paulsen

In *Report from Iron Mountain,* we read:

> War is not, as is widely assumed, primarily an instrument of policy utilized

by nations to extend or defend their expressed political values or their economic interests. On the contrary, it is itself the principal basis of organization on which all modern societies are constructed. The common proximate cause of war is the apparent interference of one nation with the aspirations of another. But at the root of all ostensible differences of national interest lie the dynamic requirements of the war system itself for periodic armed conflict. Readiness for war characterizes contemporary social systems more broadly than their economic and political structures, which it subsumes.

The handshake as ancient ritual of war

To say that "readiness for war characterizes contemporary social systems" is saying no more than that the customary handshake is a ritual form of tribal hostility used to maintain a diplomatic or armed truce between entities. Such indeed was the origin of the handshake, as one can read in detail in José Ortega y Gasset's *Man and People*. All courtesy and ceremony have this function of putting limits to aggressive emotions. In the Oriental world, where the excessive proximity of too numerous a population breeds intense aggressiveness, it has been found inexpedient to use personal pronouns. Such address draws too much attention to the unpleasant presence.

This is the terrible thing about these two personal pronouns [I and you]—willy-nilly, they are two explosions of "humanity." We can well understand Michelet's remark *Le moi est haïssable,* "The I is odious." This proves—and to spare—that the meanings of the *I* and the *you* are superconcrete, that they resume two lives in a superlatively con-

densed form which, for that very reason, is highly explosive. That is why their abuse is so annoying, and it is perfectly understandable that courtesy curtails their employment, to keep our personality from weighing too heavily on our neighbor, oppressing and wearing him down. Courtesy, as we shall see later, is a social technique that eases the collision and strife and friction that sociality is. Around each individual it creates a series of tiny buffers that lessens the other's bump against us and ours against the other.

It was Emerson who observed that manners were made to keep fools at a distance. The contemporary version of this is: " 'Shut Up,' he explained." Ortega y Gasset continues:

That courtesy was able to attain its most perfect, richest, and most refined forms ... in the Far East, in China and Japan, where men have to live too close to one another, almost on top of one another.

The house of a Atreox is fallen indeedust (Ilyam, Ilyum!...) averging on blight...
FW 55.

Without all those little buffers, living together would be impossible. It is well known that the European in China produces the impression of a rude, crass, and thoroughly ill-educated being. So it is not surprising that the Japanese language has succeeded in suppressing those two slightly and sometimes more than slightly impertinent pistol-shots the *you* and the *I*, in which, whether I want to or not, I inject my personality into my neighbor and my idea of his personality into the You. In Japan both these personal pronouns have been replaced by flowery ceremonial phrases, so that, instead of "you," one says something like "the miracle that is here," and instead of "I" something like "the wretchedness here present."

The corporate word from the old men from Iron Mountain is that war is an inseparable feature of the economic establishment:

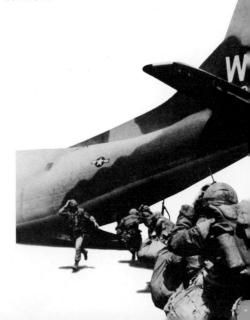

The "world war industry," as one writer has aptly called it, accounts for approximately a tenth of the output of the world's total economy. Although this figure is subject to fluctuation, the causes of which are themselves subject to regional variation, it tends to hold fairly steady. The United States, as the world's richest nation, not only accounts for the largest single share of this expense, currently upward of $60-billion a year, but also "...has devoted a higher *proportion* [emphasis added] of its gross national product to its military establishment than any other major free world nation. This was true even before our increased expenditures in Southeast Asia."

They are eager to absorb the war operations into the economic orbit:

We find further that most of the confusion surrounding the myth that war-

"War Spurs
Economies
of a Strug
gling Asia
—Headline
January 19
196

But's
wrath's
the higher
where those
wreathe
charity.
FW 251.

making is a tool of state policy stems from a general misapprehension of the functions of war. In general, these are conceived as: to defend a nation from military attack by another, or to deter such an attack; to defend or advance a "national interest"—economic, political, ideological; to maintain or increase a nation's military power for its own sake. These are the visible, or invisible, functions of war. If there were no others, the importance of the war establishment in each society might in fact decline to the subordinate level it is believed to occupy. And the elimination of war would indeed be the procedural matter that the disarmament scenarios suggest.

But there are other, broader, more profoundly felt functions of war in modern societies. It is these invisible, or implied, functions that maintain war-readiness as the dominant force in our societies. And it is the unwillingness or inability of the writers of disarmament scenarios and reconversion plans to take them into account that has so reduced the usefulness of their work, and that has made it seem unrelated to the world we know.

... old man without a thing in his ignorance,... FW 125.

The old men from Iron Mountain have not a clue to the origins or persistence of war as a quest for that identity that is always threatened by technological innovations. They are quite aware of the vast research and development activities that are accelerated by war, but it has never occurred to them that the innovations resulting from this research and development are precisely the ones that obliterate the identity image, indispensable to peace and tranquillity among nations. For example, the atom bomb, the fine flower of

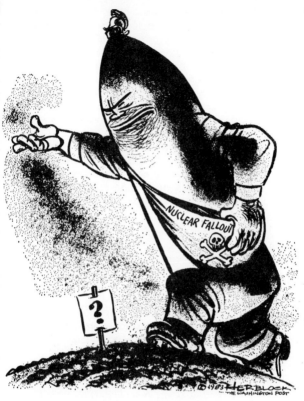

the scientific efforts spurred by the Second War, has hastened the arrival of "software" and automation that are swiftly undermining the entire industrial establishment so long devoted to hardware. Electric "software" abolishes the division between industrial worker and savant as much as between civilian and soldier.

The old men from Iron Mountain are loyal to the iron law of work and wages and all the other iron-clad laws of conventional economics that were developed in the age of hardware.

The relationship of war to scientific research and discovery is more explicit. War is the principal motivational force for the development of science at every level, from the abstractly conceptual to the narrowly technological. Modern society places a high value on "pure" science, but it is historically inescapable that all the significant discoveries that have been made about the natural world have been inspired by the real or imaginary military necessities of their epochs. The consequences of the discoveries have indeed gone far afield, but war has always provided the basic incentive.

Beginning with the development of iron and steel, and proceeding through the discoveries of the laws of motion and thermodynamics to the age of the atomic particle, the synthetic polymer, and the space capsule, no important scientific advance has not been at least indirectly initiated by an implicit requirement of weaponry. More prosaic examples include the transistor radio (an outgrowth of military communications requirements), the assembly line (from Civil War firearms needs), the steel-frame building (from the steel battleship), the canal lock, and so on. A typical adaptation can be seen in a device as modest as the common lawnmower; it developed from the revolving scythe devised by Leonardo da Vinci to precede a horse-powered vehicle into enemy ranks.

When the old men from Iron Mountain turn to more psychological aspects of war, they see it as a means that "enables the physically deteriorating older generation to maintain its control of the younger, destroying it, if necessary." Can we detect here an intuition to rival *Lord of the Flies*

or the "territoriality" of Robert Ardrey?
There follows a meditation on what Toyn-
bee calls "etherealization" or the philo-
sophical functions of war:

> *War as an ideological clarifier.* The
> dualism that characterizes the tradi-
> tional dialectic of all branches of
> philosophy and of stable political rela-
> tionships stems from war as the proto-
> type of conflict. Except for secondary
> considerations, there cannot be, to put
> it as simply as possible, more than two
> sides to a question because there can-
> not be more than two sides to a war.

> *War as the basis for international under-
> standing.* Before the development of
> modern communications, the strategic
> requirements of war provided the only
> substantial incentive for the enrichment
> of one national culture with the achieve-
> ments of another. Although this is still
> the case in many international relation-
> ships, the function is obsolescent.

> We have also forgone extended char-
> acterization of those functions we as-
> sume to be widely and explicitly recog-
> nized. An obvious example is the role
> of war as controller of the quality and
> degree of unemployment. This is more
> than an economic and political sub-
> function; its sociological, cultural and
> ecological aspects are also important,
> although often teleonomic. But none af-
> fects the general problem of substitu-
> tion. The same is true of certain other
> functions; those we have included are
> sufficient to define the scope of the
> problem.

Violence in its many forms, as an involun-
tary quest for identity, has in our time
come to reveal the meaning of war in
entirely new guise. This is a dimension of

war totally invisible to the old men from Iron Mountain. War is a sizeable component in the educational industry, being itself a form of education.

War as an accelerated program of education—compulsory education for the other party—is obvious the moment that it is mentioned. Just why it has not been mentioned very much may be explained in the lines of Alexander Pope, if for his opening word, "vice," we substitute the word "war":

**War is a monster of so frightful mien,
As, to be hated, needs but to be seen;
Yet seen too oft, familiar with its face,
We first endure, then pity, then embrace.**

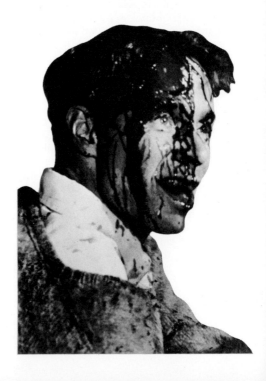

Why we lose
a few advertising pages
now and then.

When there are wars, riots, disasters, Life brings them to you. Life shows you life the way it is. Because we think you should see it the way it is. Sometimes it's pretty strong medicine.

And even though we print more fashion news, more great art, more ideas in architecture, and more food articles than most specialty magazines, we've been known to scare off an advertiser by our commitment to reporting news the way it happens.

We're doing a lot of things to change this world of ours. But changing the news is not one of them. No matter who wants us to. Maybe that's what makes Life the force it is.

Life. Consider the alternative.

In any war the foe studies the resources and characteristics of his attacker as earnestly as the attacker tries to understand the foe in depth. The generals and their staffs discuss and meditate on every aspect of the enemies' psychology, studying their cultural histories and resources and technologies, so that today war, as it were, has become the little red schoolhouse of the global village. It's a gory little schoolhouse at that. Alexander the Great and Caesar and Napoleon were accompanied on their campaigns by crowds of scholars and linguists to advise them on every aspect of the enemy's patterns of culture and, of course, to loot any cultural treasures of the enemy that could be conven-

...all differing as clocks from keys since nobody appeared to have the same time of beard,... FW 77.

iently seized. Today, in the light of our information systems for getting inside the enemy psyche, as it were, the arrangements of these historical conquerors merely resemble some gathering of savants at some cosmopolitan hotel.

It is the theme of this section that new technology disturbs the image, both private and corporate, in any society, so much so that fear and anxiety ensue and a new quest for identity has to begin. Nobody has ever studied what degree of innovation is required to shatter the self-image of a man or a society. In our time, at least, the amount of innovation far exceeds all the impacts of innovation of all the past cultures of the world. We are more frantic to recover and put together the pieces of the shattered image than any past society whatever. It is this impulse that motivates the orgy of rear-view mirrorism, everything from the scholarly reconstruction of remote and dinky cultures to *Gone With the Wind*.

You is feeling like you was lost in the bush, boy?
FW 112.

When a new technology strikes a society, the most natural reaction is to clutch at the immediately preceding period for familiar and comforting images. This is the world of *The Virginian* and *Bonanza* and frontier entertainment. If 90 per cent of all the scientists who ever lived are now alive, we might say that Hollywood houses more redskins and more cowpunchers than ever existed on the frontier. What is called progress and advanced thinking is nearly always of this rear-view mirror variety. Desmond Morris put it very well in *The Naked Ape*. Instead of saying that our space program is Newtonian and obsolete in its very beginnings, he says: "The space

ape still carries a picture of his wife and children with him in his wallet as he speeds towards the moon." All the money that is being spent in NASA is exactly on a par with the budget for *Bonanza*. It is a Newtonian program, not a twentieth-century program. It is a misappropriation of funds. It has no relevance to our time anymore than *Bonanza* does. Projecting missiles into outer space is no different from the activities of Columbus and Magellan.

The new space, created by our electronic microscopes, points to the immediate possibilities of anti-gravitational transportation such as would eliminate the wheel and the miseries of our cities. The same rear-view pattern appears in connection with every innovation whatever. When anesthetics were discovered, they were naturally applied to surgery. Surgery was not new. The anesthetic was new. Moreover, the anesthetic made possible fiendish human torments that transferred all the human pain to convalescence. With anesthetics, what was really new was convalescence. Weeks and months of pain resulted from the new technology. Nobody has ever thought of applying anesthetics to convalescence. It has been used, however, in mental hospitals for the criminally insane, where it was found possible to anesthetize for long stretches at a time without any physical damage.

For then was the age when hoops ran high.
FW 20.

As regards war itself as a quest for the recovery of identity and respect, the same rear-view mirrorism is always present. In 1914 the Kaiser protested that Germany had become encircled as a result of the industrial advance of the Slavic peoples. The industrial development of backward

countries, such as Hungary and Poland, disturbed the psychic balance and identity image of the Germans. A parallel situation exists today in our tribal, global village. All the non-industrial areas like China, India, and Africa are speeding ahead by means of electric technology. This has profoundly disturbed the American image, for all these backward countries are tribal in the noblest sense of the term. That is, they have never had a nineteenth century; they have entered the twentieth century with their family kinship systems and closely integral patterns of association still intact. That is to say, they are far more "communist" than Russia, but perhaps no more "communist" than our own teen-agers are likely to become. To be surrounded by rapidly developing countries whose patterns of culture are widely divergent from our own has certainly up-

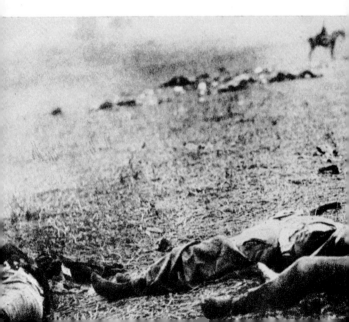

set the American image, at least among the elders. Our confused efforts to re-establish goals, habits, attitudes, and the sense of security they bring have become the main order of business.

Another way of approaching this matter is to observe the social effects of fighting a war by railway. The American Civil War was the first railway war. The mobilization of men and materials took on a brand-new character which was carefully studied by general staffs of the European countries. Railways were an incidental accompaniment of industrialization in the quest for raw materials and markets alike. All the industrial features were then extended to war and just as every citizen had been a worker, every citizen became a soldier. Previous wars had had no such scope.

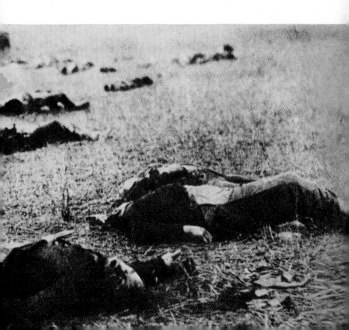

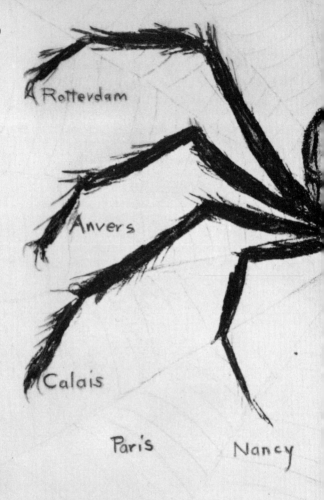

A Rotterdam

Anvers

Calais

Paris

Nancy

The Kaiser, in 1915: "The Greater Germany must one day dominate the whole of Europe."

Maroc Algère

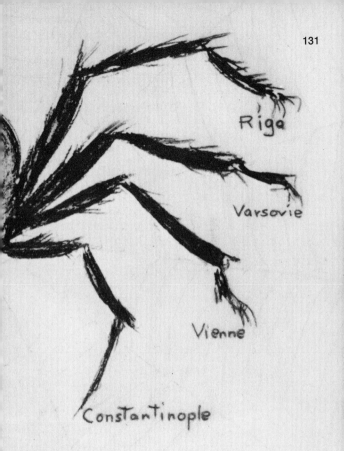

Riga

Varsovie

Vienne

Constantinople

Bagdad

Louis Raemaekers

The First World War was also a railway war, enormously exaggerated in scope and destruction by the extension of industrialism and the enlargement of cities. It was a war of massed armies, massed guns. At the battle of the Somme, the Germans brought six thousand cannon into place simultaneously.

The Second World War was a radio war as much as it was an industrial war. The radio phase of electronics had awakened the tribal energies and visions of the European peoples in a way that television is now doing to America. Unlike Europe, America has no tribal past. Radio, thus, did not appeal to any distant images of tribal unity and strength. It awakened the energies of the Negro and enabled him to

dominate the culture of the 1920's in the United States through his tribal songs and dances. When the war babies and the jazz babies reached the job plateau in the late 1920's, they rejected the goals and objectives of their elders sufficiently to create an economic slump. Of course, it was as nothing compared to the present slump that is just beginning with the aid of television. The radio slump or depression of 1929-1939 was the result of switching the vision of a whole population from visually conceived objectives to the total field of polarized energies that automatically goes with radio and auditory space.

In the ignorance that implies impression that knits knowledge that finds the name-form that whets the wits that convey contacts that sweeten sensation that drives desire that adheres to attachment that dogs death that bitches birth that entails the ensuance of existentiality. FW 18.

The United States is by far the most visually organized country in the history of the world. It is the only country that was ever founded on the basis of phonetic literacy for all. All of its political and business institutions assume the ground plan of this literacy. All of its production and consumption techniques are expressions of the same literacy: Labels and classifications for everything and everybody.

Radio was a disaster for a goal-oriented America. It inspired multiple goals and a multiplicity of new images, depriving the country of a simple visual-mindedness which was unprecedented in all political history. The war of 1939 meant a recapturing of some of the blueprints and visual-mindedness that had been blurred by radio. Just before the war, Roosevelt discovered the means of making the radio fireside chat a kind of firing line, a new kind of political violence to recover the sense of identity. The war of 1939-1945 pulled us out of the depression created by the new total field sensibility of radio, but it also created many new marriages between the old mechanical industries and the new electric technologies that were as destructive of the American sense of identity as radio itself. The airplane is an example of one of these weddings, and its effect upon rail travel will serve as an indication of the kinds of psychic changes that go with such innovations.

We are now in the midst of our first television war. Television began to be experienced in the ordinary home after 1946. Typically, the FBI and the CIA were looking in the rear-view mirror for the revolutionary agents who were threatening the identity of the country. The television environment was total and therefore invisible. Along with the computer, it has altered every phase of the American vision and identity. The television war has meant the end of the dichotomy between civilian and military. The public is now participant in every phase of the war, and the main actions of the war are now being fought in the American home itself.

That the war is being fought in the American home as much as in Vietnam can be illustrated by noting some of the favorite music, painting, and literature of the young teen-agers, for nearly all of whom this war and all wars are anathema. To mention the Beatles is to evoke an image of non-melodic, Oriental, and environmental resonance. The writings of John Cage are a monument to this revolution in which music departs from a narrative or story line *(melos hodos*—melody, the musical road). There is no melody in primitive or Oriental music because the road of song is a continuum known only to literate man.

Song itself is a slowing down of speech so that the songs of each culture are uniquely patterned by their speech. This is equally true of dance, since every culture that is or ever was in the world possesses a unique ratio of sensory life that can be detected at once in its speech, its dances, or its songs. Any technological innovation in any culture whatever at once changes all these sensory ratios, making all the older songs and dances seem very odd and dated to the young. In all cases sensory change is levered by new technical innovations, since new technology inevitably creates new environments that act incessantly on the sensorium. Failure to grasp this etiological and ecological fact now makes the work of Marx look as empty as that of Spengler. These giants spent their lives building up a descriptive story of changes for which they could assign no causes whatever.

Yet without the cause counteraction is impossible and the writer can merely ride the wave of change like a surfboarder. He may look very graceful and skillful but the wave remains quite independent of him. Knowing the cause, it at least becomes optional whether one wishes to remove it or counteract it. For example, the Dutch elm disease which was brought on by accident during research experiments can be defeated at a cost of $2,500 per tree, but it requires that all of the trees be so treated. One tree cannot be saved by itself. Is not this somewhat like the human condition in general? These self-amputations which we call new technologies generate vast new environments against which the individual organism is quite helpless.

... speared the rod and spoiled the lightning; ... FW 131.

Let us now, weather, health, dangers, public orders and other circumstances permitting, of perfectly convenient, if you police, after you, policepolice pardoning mein, ich beam so fresch, bey?... FW 113.

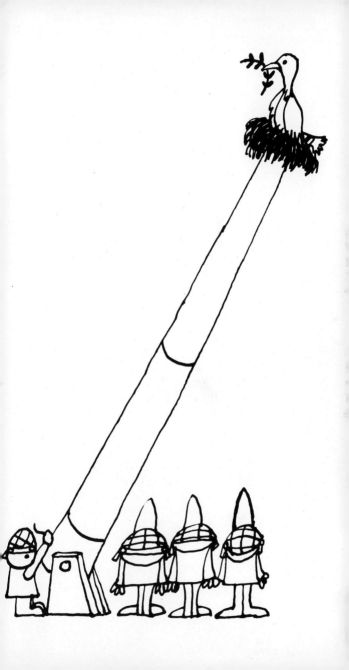

The turned-on effect which penetrates the television generation (fifteen years and under) inspires them to read books like *Siddhartha* by Hermann Hesse. Hesse was a favorite of intellectuals in the 1920's and plays a considerable role in *The Waste Land*. *Siddhartha* is a story of violence as a quest for identity. It concerns the odyssey of the gifted son of a wealthy Brahmin who leaves home to become a Samana. Asceticism or self-denial is as much a form of violence, a way of discovering one's own inner boundaries and territorialities, as war or education.

On the evening of that day they overtook the Samanas and requested their company and allegiance. They were accepted.

Siddhartha gave his clothes to a poor Brahmin on the road and only retained his loincloth and earth-colored unstitched cloak. He only ate once a day and never cooked food. He fasted fourteen days. He fasted twenty-eight days. The flesh disappeared from his legs and cheeks. Strange dreams were reflected in his enlarged eyes. The nails grew long on his thin fingers and a dry, bristly beard appeared on his chin. His glance became icy when he encountered women; his lips curled with contempt when he passed through a town of well-dressed people. He saw businessmen trading, princes going to the hunt, mourners weeping over their dead, prostitutes offering themselves, doctors attending the sick, priests deciding the day for sowing, lovers making love, mothers soothing their children—and all were not worth a passing glance, everything lied, stank of lies; they were all illusions of sense, happiness and beauty. All were doomed to decay. The world tasted bitter. Life was pain.

... the innocent exhibitionism of those frank yet capricious underlinings: that strange exotic serpentine, since so properly banished from our scripture, about as freakwing a wetterhand now as to see a rightheaded ladywhite don a corkhorse, ...
FW 121.

"Siddhartha," by Hermann Hesse, translated by Hilda Rossner. Copyright 1951 by New Directions Publishing Corporation. Peter Owen and Vision Press.

Siddhartha had one single goal—to become empty of thirst, desire, dreams, pleasure and sorrow—to let the Self die. No longer to be Self, to experience the peace of an emptied heart, to experience pure thought—that was his goal. When all the Self was conquered and dead, when all passions and desires were silent, then the last must awaken, the innermost of Being that is no longer Self—the great secret!

Silently Siddhartha stood in the fierce sun's rays, filled with pain and thirst, and stood until he no longer felt pain and thirst. Silently he stood in the rain, water dripping from his hair on to his freezing shoulders, on to his freezing hips and legs. And the ascetic stood until his shoulders and legs no longer froze, till they were silent, till they were still. Silently he crouched among the thorns. Blood dripped from his smarting skin, ulcers formed, and Siddhartha remained stiff, motionless, till no more blood flowed, till there was no more pricking, no more smarting.

Expressed in terms of our Western environment today the Samana strategy would consist in creating an environment untouched by any technology whatever so that there would be no inputs for the sensorium and hence no processing of any inputs such as constitutes experience or sensory "closure." Literate man easily imagines that there is a direct correspondence between the input and the experience. He lives in a world of correspondences and matchings and repetitions which he calls rationality and science. Until fairly recently any set-up was scientific if it could be exactly reproduced or repeated. This, of course, can never happen in any moment of human experience. Every input is totally transformed.

Gradually, Siddhartha discovers that no form of self-denial can alter the fact that environments as inputs are profoundly shaped by the individual. This part of the novel is called "Awakening."

> He reflected deeply, until this feeling completely overwhelmed him and he reached a point where he recognized causes; for to recognize causes, it seemed to him, is to think, and through thought alone feelings become knowledge and are not lost, but become real and begin to mature.

It strikes him that:

> The reason why I do not know anything about myself, the reason why Siddhartha has remained alien and unknown to myself is due to one thing ...fleeing from myself.

Instead of trying to gain power over and independence of the world by stifling the various inputs of sensation from the environment, Siddhartha decides to try an even more violent experiment by plunging in depth into the world and by allowing it to shape him completely:

... making his pillgrimace of Childe Horrid, engrossing to his ganderpan what the idioglossary he invented under hicks hyssop!
FW 423.

> Yes, he thought breathing deeply, I will no longer try to escape from Siddhartha. I will no longer devote my thoughts to Atman and the sorrows of the world. I will no longer mutilate and destroy myself in order to find a secret behind the ruins. I will no longer study Yoga-Veda, Atharva-Veda, or asceticism, or any other teachings. I will learn from myself, be my own pupil; I will learn from myself the secret of Siddhartha.

The new strategy of exploration which he sets himself reads very much like the ordinary Western program for self-development:

**You'll love our 10:30 A.M. flight to Jamaica.
Especially around 2:30 in the afternoon.**

ie nice thing about flying Air Jamaica to Jamaica is that we leave before anyone else.
A.M. every day from Kennedy.
1d because we leave for Jamaica before anyone else, we also arrive in Jamaica before anyone else.
M. in Montego Bay.
you actually get four hours on the beach on the first day of your vacation. Four hours to get your
t, and your body headed brownward.
that isn't a good enough reason to fly with us to Jamaica, here are three more: giant Rolls-Royce
jets, experienced BOAC pilots, and luscious stewardesses.
r reservations, see your Travel Agent. Or get in touch with us through BOAC at MU 7-1600.

New York-Jamaica services operated for Air Jamaica by BOAC.

Air Jamaica
We'll get you to Jamaica first.

He looked around him as if seeing the world for the first time. The world was beautiful, strange and mysterious. Here was blue, here was yellow, here was green, sky and river, woods and mountains, all beautiful, all mysterious and enchanting, and in the midst of it, he, Siddhartha, the awakened one, on the way to himself. All this, all this yellow and blue, river and wood, passed for the first time across Siddhartha's eyes. It was no longer the magic of Mara, it was no more the veil of Maya, it was no longer meaningless and the chance diversities of the appearances of the world, despised by deep-thinking Brahmins, who scorned diversity, who sought unity. River was river, and if the One and Divine in Siddhartha secretly lived in blue and river, it was just the divine art and intention that there should be yellow and blue, there sky and wood —and here Siddhartha. Meaning and reality were not hidden somewhere behind things, they were in them, in all of them.

He encounters the courtesan Kamala and realizes at once that in order to possess her he must become immensely wealthy:

Siddhartha saw how beautiful she was and his heart rejoiced. He bowed low as the sedan chair passed close by him, and raising himself again, gazed at the bright fair face, and for a moment into the clever arched eyes, and inhaled the fragrance of a perfume which he did not recognize. For a moment the beautiful woman nodded and smiled, then disappeared into the grove, followed by her servants.

He associates himself with a merchant named Kamaswami. Siddhartha's ample Brahmin training becomes a great resource for the merchant:

Siddhartha learned many new things; he heard much and said little. And remembering Kamala's words, he was never servile to the merchant, but compelled him to treat him as an equal and even more than his equal. Kamaswami conducted his business with care and often with passion, but Siddhartha regarded it all as a game, the rules of which he endeavored to learn well, but which did not stir his heart.

Having enriched himself and attired himself like a dandy, he approaches and is accepted by Kamala: "Here with Kamala lay the value and meaning of his present life, not in Kamaswami's business." Siddhartha's complex background gave him easy superiority in the business world. As Kamaswami put it:

> "This Brahmin," he said to a friend, "is no real merchant and will never be one; he is never absorbed in the business. But he has the secret of those people to whom success comes by itself, whether it is due to being born under a lucky star or whether it is magic, or whether he has learned it from the Samanas. He always seems to be playing at business, it never makes much impression on him, it never masters him, he never fears failure, he is never worried about a loss."

So far Siddhartha's program of action is entirely consistent with any Western pattern of culture:

> Siddhartha had learned how to transact business affairs, to exercise power over people, to amuse himself with women; he had learned to wear fine clothes, to command servants, to bathe in sweet-smelling waters. He had learned to eat sweet and carefully prepared foods,

Ann alive, the lisp of her, . . . her dabblin drolleries, for to rouse his rudderup, or to drench his dreams. FW 139.

also fish and meat and fowl, spices and dainties, and to drink wine which made him lazy and forgetful.... But slowly and imperceptibly, with the passing of the seasons, his mockery and feeling of superiority diminished. Gradually, along with his growing riches, Siddhartha himself acquired some of the characteristics of the ordinary people, some of their childishness and some of their anxiety. And yet he envied them; the more he became like them, the more he envied them.

... and still one feels the amossive silence of the cladstone allegibelling: Ive mies outs ide Bourn.) FW 31.

Life having lost all meaning once more, he has wandered and taken his repose by a tree on the river bank, "placed his arm around the trunk, and looked down into the green water that flowed beneath him." He is assailed by a temptation to suicide but falls asleep and is reborn: "At that moment when the sound of Om reached Siddhartha's ears, his slumbering soul suddenly awakened and he recognized the folly of his action." He realizes that he has entered upon an entirely new phase of his life:

Poof! There's puff for ye, begor, and planxty of it, all abound me breadth! FW 439.

He was going backwards, and now he again stood empty and naked and ignorant in the world. But he did not grieve about it; no, he even felt a great desire to laugh, to laugh at himself, to laugh at this strange foolish world!

Things are going backwards with you, he said to himself and laughed, and as he said it, his glance lighted on the river, and he saw the river also flowing continually backwards, singing merrily. That pleased him immensely; he smiled cheerfully at the river. Was this not the river in which he had once wished to drown himself—hundreds of years ago—or had he dreamt it?

He is caught up in the mythic pattern of the perpetual return which unites and cleanses:

> I will remain by this river, thought Siddhartha. It is the same river which I crossed on my way to the town. A friendly ferryman took me across. I will go to him. My path once led from his hut to a new life which is now old and dead. May my present path, my new life, start from there!

> He looked lovingly into the flowing water, into the transparent green, into the crystal lines of its wonderful design. He saw bright pearls rise from the depths, bubbles swimming on the mirror, sky blue reflected in them. The river looked at him with a thousand eyes—green, white, crystal, sky blue.

This kind of story is today a popular bestseller among teen-agers. They, too, feel alienated from a fragmented, mechanical world, the classified patterns of which have merely presented a slot for each person. The draft card represents, as an extreme, a form of classified slot, as they can imagine. Our cities and schools seem to them almost as meaningless in presenting unrelated and non-integral patterns of experience. Unlike the Negro, who gets "turned on" by our new electric environment and feels anger at the literate establishment that had previously degraded him, the wasp world of teen-agers is on the whole turned off by electronic culture. At least he is alienated from his own heritage of 2,500 years of literacy. (Of course, all American Catholics are wasps, there being no Catholic culture whatever in the United States.)

. . . how on the owther side of his big belttry your tyrs and cloes your noes and paradigm maymay rererise in eren. FW 53.

Education as War:

There is a rather tenuous division between war as education and education as war. Frequent references occur to the revolution in farming that goes hand-in-hand with our fighting in Vietnam. Perhaps less obvious is the aggressive and military character of sending medical missionaries, at the expense of the Ford Foundation, to India to implement birth control campaigns. In the information age it is obviously possible to decimate populations by the dissemination of information and gimmickry. There is no question here of values. It is simple information technology being used by one community to reshape another one. It is this type of aggression that we exert on our own youngsters in what we call "education." We simply impose upon them the patterns that we find convenient to ourselves and consistent with the available technologies. Such customs and usages, of course, are always past-oriented and the new technologies are necessarily excluded from the educational establishment until the elders have relinquished power. This, of course, leaves the new technologies entirely in the sphere of entertainment and games: "Wipe your sinses with what you know."

B. F. Skinner's *Walden Two* is much concerned with the theme of education as war:

> "After all, it's a simple and sensible program," he went on in a tone of appeasement. "We set up a system of gradually increasing annoyances and frustrations against a background of complete serenity. An easy environment is made more and more difficult as the children acquire the capacity to adjust."

Admittedly it is an outer husk: its face, in all its featureful perfection of imperfection, is its fortune: it exhibits only the civil or military clothing of whatever passion-pallid nudity or plague-purple nakedness may happen to tuck itself under its flap. FW 109.

"Walden Two," by B. F. Skinner. The Macmillan Company. Copyright 1948 by B. F. Skinner.

Skinner realizes that education is profoundly involved in pain, but in *Walden Two* he shows how well he understands the difference between personal and environmental pain. As a psychologist, he realizes that it is the content of environments, especially educational environments, that inflicts most of the unnecessary pain:

> "If I must spell it out," Frazier began with a deep sigh, "what they get is escape from the petty emotions which eat the heart out of the unprepared.

They get the satisfaction of pleasant and profitable social relations on a scale almost undreamed of in the world at large. They get immeasurably increased efficiency, because they can stick to a job without suffering the aches and pains which soon beset most of us. They get new horizons, for they are spared the emotions characteristic of frustration and failure."

The reason that children learn a language in a year or two is simply because it is an environment. Educationally, there is no reason why physics and mathematics cannot be given the same environmental codification and learned with the same speed and ease. Archibald MacKinnon, Dean of Education at the University of British Columbia, has been carrying out experiments in recent years that illustrate this principle. He has been borrowing natives from the deepest jungles of the world and exposing them to sophisticated situations without any training in our Western knowledge. For example, he allows them to explore four-engine jet airplanes, and within three or four months they not only fly them but can assemble and repair any part of the mechanism of these planes. During the Second War, the American Air Force stationed at Gander, Newfoundland, found that the top technicians were Eskimo hunters who had never seen a machine before. The so-called primitive man does not relate himself to a machine as we do. Rather, he regards it as we do a pet animal, as integral and alive. Assuming its total unity, he apprehends it as such, just as a child when listening to a strange language assumes that it has meaning and organization. In both cases it is a total field approach, and this is

Yet to concentrate solely on the literal sense or even the psychological content of any document to the sore neglect of the enveloping facts themselves circumstantiating it is just as hurtful to sound sense ... FW 109.

the only kind of approach that will work under electric conditions of our new environment.

Whosaw the jackery dares at handgripper thisa breast? Dose makkers ginger. Some one we was with us all fours. FW 535.

Our own youngsters who have grown up in an electric environment naturally approach it in the same way that MacKinnon's natives do a jet plane. This makes it very difficult for them to establish any meaningful relationship with the older education based on fragmented and classified data. To educate the "turned-on" teen-ager in the old mechanical style is like asking a three-year-old who has just learned English to talk pidgin-English or to use a heavy Scottish brogue. These things are not in his environment and therefore not cognizable.

Bad news concerns few, but good news can upset a whole culture

The world of advertisements has for a century been a frank declaration of war on the community of customers. *The Wall Street Journal* published an AVCO advertisement:

WE ARE 25,000 PEOPLE
CHANGING THE WAY YOU LIVE...

AN UNUSUALLY BROAD RANGE
OF COMMERCIAL
DEFENSE AND SPACE CAPABILITIES
IDENTIFIED BY THIS NEW SYMBOL.

This illustrates a recent tendency of masochistic self-immolation on the part of advertisers. They have discovered the great principle that real news is bad news. Up till now advertising has been all good news and, therefore, gets very little attention. Another ad recently read:

THE TREE THAT GROWS IN BROOKLYN
IS A FRAUD

and, of course we are all familiar with the Pat Paulsen-sort of sick whimsies provided by Avis and Hertz. But advertising as an educational onslaught, a massive barrage against human sensibilities, is too familiar to need further comment here. There are greener fields and many current examples.

The Ford Foundation's campaign against the Indian population has already been mentioned. Ideally, the populations of India, China, and Japan would have to be reduced to a quarter or less of their present size in order to make possible for these peoples anything resembling the suburban life of America. War has always been a form of compulsory education for the other guy, but even the greatest ravagers of mankind never dreamed of destroying as many people as these educators hope to do. Their ostensible motive is to cut down the population to the point where everybody can have three squares a day. Meanwhile, our scientists are explaining how it will soon be possible to produce on any given acre ten times more food than at present. Naturally, the Ford Foundation teams are approaching the population problem on the production-consumption bases familiar to our mechanical world. It may well prove that there is a considerable irrelevance in their entire assumptions when they come to grips with an Oriental culture.

Why such an order number in preference to any other number? Why any number in any order at all? FW 447.

"You will find an account of that bit of social engineering in a manuscript in one of the libraries," said Frazier. "It's called 'The Bore War.' The rule was regarded as a doubtful experiment, but it was put over quite successfully."

Here's our dozen cousins from the starves on tripes. FW 265.

The Bore War:

Many people have commented on clothing as weaponry, as Carlyle did on institutions as clothing, but there are a good many unexplored facets of the topic of clothing and fashion. Some of them appeared in the Algerian episodes of 1954–1958. For a century the French had made strenuous efforts to induce their Arab colonials to strip off the purdah. In the "troubles" of 1954–1958, things were reversed. The Arabs themselves actually did have their women take off the purdah so that they might infiltrate the enemy ranks in European guise. It was also hoped that they would be able to place bombs and other destructive weaponry in strategic places. Without the purdah these hapless females were not only unable to infiltrate European precincts, they were unable to cross the street. The stark, staring confrontation with motor cars and buses induced hysteria. Even worse, when they resumed the purdah and returned to their old surroundings, they discovered that they had become utterly alienated from them and had undergone a radical sensory change. In a less spectacular way, dance band members have found that a change of costume has made it quite impossible to play former numbers at which they were very proficient.

Frantz Fanon discusses clothing as weaponry in *Studies in a Dying Colonialism:*

> The body of the young Algerian woman, in traditional society, is revealed to her by its coming to maturity and by the veil. The veil covers the body and disciplines it, tempers it, at the very time when it experiences its phase of greatest effervescence. The veil protects, reassures, isolates. One must have heard the con-

So then she started raining, raining, and in a pair of changers, be dom ter, she was back again at Jarl von Hoother's and the Larryhill with her under her abromete. And why would she halt at all if not by the ward of his mansion-home of another nice lace for the third charm? FW 22.

fessions of Algerian women or have analyzed the dream content of certain recently unveiled women to appreciate the importance of the veil for the body of the woman. Without the veil she has an impression of her body being cut up into bits, put adrift; the limbs seem to lengthen indefinitely. When the Algerian woman has to cross the street, for a long time she commits errors of judgment as to the exact distance to be negotiated. The unveiled body seems to escape, to dissolve. She has an impression of being improperly dressed, even of being naked. She experiences

The ladies
have
mercias !
It brought
the dear
prehistoric
scenes all
back again,
. . . FW 385.

a sense of incompleteness with great intensity. She has the anxious feeling that something is unfinished, and along with this a frightful sensation of disintegrating. The absence of the veil distorts the Algerian woman's corporal pattern. She quickly has to invent new dimensions for her body, new means of muscular control. She has to create for herself an attitude of unveiled-woman-outside. She must overcome all timidity, all awkwardness (for she must pass for a European), and at the same time be careful not to overdo it, not to attract notice to herself. The Algerian woman who walks stark naked into a European city relearns her body, re-establishes it in a totally revolutionary fashion. This new dialectic of the body and of the world is primary in the case of one revolutionary woman.

At a quite different level, Africans attempting to acquire literacy have found it expedient to wear European costume for the simple reason that it retains a great deal more bodily heat and energy than their native costume. The act of reading printed matter drains off a huge proportion of the human energy, as any convalescent knows. Anthropologists are well acquainted with the fact that the scantily-clad native can go without food and water for a very brief period because of the rapid dissipation of his energies over the entire surface of his exposed body. Without food and water he's finished in twenty-four hours. On the other hand, the heavily clad Eskimo in a most inhuman environment can last for six to seven days without food or water. In contrast to the Western function of clothing, desert dwellers wear heavy clothing to exclude the heat.

... lived in the broadest way immargin-able ...
FW 4.

A baser meaning has been read into these characters the literal sense of which decency can safely scarcely hint.
FW 33.

Love my label like myself.
FW 579.

These are all simple cases of clothing as weaponry designed to combat hostile conditions, and an inventory of such weaponry could easily be extended. Clothing as an extension of the human skin is as much a technology as the wheel or the compass. Strangely, the world of fashion has never been approached from this point of view. Is it merely a "bore war"? Is it merely an attempt to add a bit of spice and variety to the monotony of life? Possibly the fact that there is no such thing as fashion in native societies may provide an approach to this question. In these societies clothing indicates age and status and serves complex ritual functions that relate the energies of the tribe to cosmic forces as much as we relate our energies to tanks and airplanes. Clothing is power and the or-

I dreamed I drove them wild in my *maidenform bra*

COUNTERPOINT*...new Maidenform bra made with super-strong Spandex—new, non-rubber elastic that weighs almost nothing at all yet lasts (and underlinecontrols you) far longer than ordinary elastic. Exclusive "butterfly insert" adjusts size and fit of each cup as it uplifts and separates! Cotton or Spandex back. White. From 2.00.

ganization of human energy, both private and corporate. In tribal societies they prize the integral power of the corporate far above the variations of the individual costume. In fact, when all members of the tribe wear the same costumes, they find the same psychic security that we do in living in uniform, mechanized environments. Since our environments are so drastically uniform we feel we can afford a wide play of private expression in behavior and costume. However, when we seek to rally the corporate energies for sharply defined objectives, we do not hesitate to impose uniforms. Both the military costume of the citizen as robot and the ceremonial costume of the elite at dignified functions are exact parallels to the tribal use of costume. It is somewhere in between the military uniform and the rigid fixity of formal attire that there falls the world of fashion.

One exception to all this comes to mind. The Doukhobor communities of western Canada are a religious group of Slavic origin. In their frequent collisions with Canadian bureaucracy they have a simple weapon. Men, women, and children take off all their clothes and boldly march through the wasp towns. They greatly outnumber the police. Their strategy would probably not succeed in any but wasp territory, any more than "feelthy" post cards could be sold in Paris. This is a kind of clothing warfare which is perhaps unique in human annals and it is a shame that Desmond Morris did not make use of it in *The Naked Ape.*

Regimental uniforms, then, are not fashion even when they change. Formal dress

... or to explode his twelve-chamber and force a shrievalty entrance that the heavybuilt Abelbody in a butcher-blue blouse from One Life One Suit (a men's wear store), with a most decisive bottle of single in his possession ... FW 63.

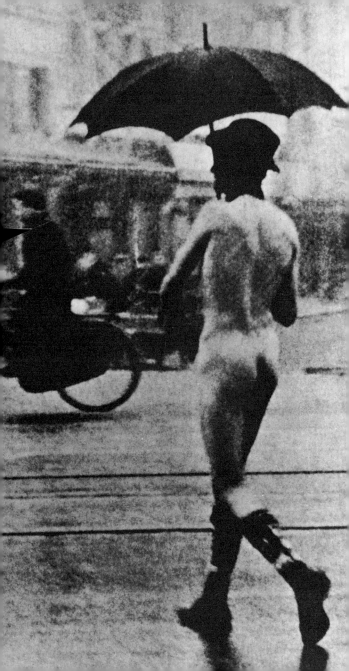

clothing is not fashion, even when it palls. Is then fashion the poor man's art? Is it an attempt to adjust the sensory life to a changing technological environment? It would seem very likely that this is the case. The teen-agers have begun to experiment with clothing as an artist does with his pigments. Many of the hippies make their own clothes and many of the clothes worn by teen-agers look as though they've never been made by anybody. There is, nevertheless, an unmistakable rapport between the shaggy and disheveled garments of the teen-aged male and the sounds of the music and the look of the art to which he also gives his loyalty. The word tactility has been frequently used in this book because after 2,500 years of visual culture the violent switch to the audile-tactile stress and resulting indifference to visual appearances is a fact that concerns all our institutions and experiences. The world of fashion, whether at the level of the slob or the snob, now has the same textural qualities that express rebellion against the departing visual values. Colors play a very large part in this rebellion. Color is apprehended not by the periphery of the eye but by the central macula, and the shift from the outer to the inner area of the eye is as much a part of the information implosion as television.

Considering clothing, then, as an anti-environmental gesture, whether physical or psychical, it becomes fascinating to study this language. The study of armor as a clothing related to the stirrup makes a nice correlation with the clothing of the cowboy or of the motor car as clothing. The rapid change of car styles points directly to the fact of its being a form of

Of course I know, pettest, you're so learningful and considerate in yourself, so friend of vegetables, you long cold cat you! FW 145.

human clothing. A page of the *Toronto Globe & Mail* (January 12, 1968) featured an article entitled "After a Fashion: Cars Parked on Turquoise Broadloom for Quiet, Comfort." Our increased involvement in rough textures as opposed to slick, metallic surfaces is a simple footnote to a changing human sensibility.

On the same newspaper page is an article headed "Mary Quant Defends Miniskirt as Irreplaceable Fashion Classic":

The Associated Press.

Mary Quant, the lioness of British fashion, leaped to defense of the miniskirt yesterday.

Jumping squarely into the squabble set off by Hardy Amies' miniless collection Wednesday, Miss Quant asserted: "The mini has built itself into a fashion classic that will never be replaced."

She got support from an unlikely quarter. Norman Hartnell, the Queen's dressmaker, commented: "The maxi or long skirt is trembling to win the fashion stakes, but it hasn't reached the winning post yet."

...the queen was steep in armbour feeling fain and furry, the mayds was midst the hawthorns shoeing up their hose, out pimps the back guards (pomp!) and pump gun they goes:...
FW 135.

Of course, the miniskirt is not a fashion. It is a return to the tribal costume worn by men and women alike in all oral societies. As our world moves from hardware to software the miniskirt is a major effort to reprogram our sensory lives in a tribal pattern of tactility and involvement. Nudity itself is not a visual so much as a sculptural and tactile experience.

Whereas clothing is the enclosed space of Western literate man, the attire of the medieval or renaissance page boy and gentleman strongly stressed a world of contours. Again, if the enclosed attire of literate man strove for individualist and

specialist effects, dichotomizing the attire of male and female, the exact opposite now seems to be true. What about the kilt? And the short traditional dress of the Greek male?

One symptom of changing sensory life amidst the new technologies is conveyed by an Associated Press story of December 27, 1967:

MEN LOSING CLOTHING INHIBITIONS

While winning equal opportunities for themselves, women have inadvertently freed men from their inhibitions about the way they dress.

"As women begin to look like and in a sense become men, the men, freed of the responsibility of running things ... become more flamboyant," James Laver, British fashion historian, recently told an interviewer.

"Man is trying to get women to notice him," Mr. Laver said, "and I don't think his interest in clothing and colognes and so on is necessarily going to make him effeminate."

The Associated Press.

Gee up, girly! The quad gospellers may own the targum but any of the Zingari shoolerim may pick a peck of kindlings yet from the sack of auld hensyne. FW 112.

So what has he been doing lately to make women notice him, now that his wife is bringing home half the rent money?

He's wearing:

—Turtlenecks. Men have probably struck their hardest blow for fashion independence by snubbing the necktie, bowtie and a variety of other starched harnesses. Though the necktie industry swears it is not choked up over the trend, the turtleneck boom is still booming.

—Fur coats. Men are wearing rugged Persian lambs cut military fashion and

moleskins in hardy trench styles. When the fur is mink, it is hidden unostentatiously as lining.

—Colored shirts. Television started it. Prominent people appearing on camera were asked to wear blue shirts because white bounces light. And since others wanted to look as though they were prominent enough to be asked to be guests on television panels, they wore blue, too. After blue, could yellow, green, or even pink be far behind?

On January 6, 1968, *The New York Times* headlined a similar article: IF A FASHION'S GOOD ENOUGH FOR HER, IT'S GOOD ENOUGH FOR HIM.

Perhaps fashion is a kind of macro gesticulation of an entire culture having a dialogue or an interfacing encounter with its new technologies.

One obvious feature of fashion is its frequent trips into the past for design loot.

Tom Hyman wrote a feature article for *The Saturday Evening Post* on the electronic clothes created by a twenty-year-old blonde "like an LSD trip with none of the hangovers":

A tall, battered wooden door, painted Day-Glo pink and blue, opens into a small loft. Inside, the first thing that greets the eye is a set of drums, set up against the far wall, flanked on one side by an amplifier and on the other by two electric guitars. Two windows are draped with American flags. Against another wall, beneath a four foot long sign that says Zooooooom! in big red letters, a workbench is cluttered with screwdrivers, pliers, soldering equipment, sketch pads, pieces of plastic,

So why, pray, sign anything as long as every word, letter, penstroke, paperspace is a perfect signature of its own? A true friend is known much more easily,... by his personal touch, habits of full or undress, ...than by his footwear, say. FW 115.

"Turn on Your Dress, Diana," by Tom Hyman. The Saturday Evening Post.

scraps of metal, strips of Plexiglas, a deck of tarot cards, paintbrushes and cans of paint. A sofa nearby sags under the weight of bolts of exotic cloth, and scattered everywhere—in boxes, on tables, chairs, stools, on the floor—lie tangles of wire, battery packs, plugs, fuses, potentiometers, switches and electroluminescent lamps. Hanging on a lamp pole is a silver-colored jump suit with wires dangling from its unzipped insides.

The room could belong to some mad engineer working on his own private space program. Or it could be a garage for repairing Hispano-Suizas. Actually, it's a dress shop.

The owner of this mechanical jungle, located in a warehouse district on East 18th Street in Manhattan, is 24-year-old Diana Dew, the inventor of the electronic dress, and by any standard the most far-out fashion designer in the world.

"My clothes are designed to turn people on," she said. "Get rid of their inhibitions. Like taking LSD—with none of the hangups.". . . Equally intriguing was a line of nightclothes and underwear treated with phosphorescent patterns that glowed in the dark. She turned out the light in the studio so I could get the full effect. "Great for making love in," she said.

When the Duke of Wellington said that the battle of Waterloo had been won on the playing fields of Eton, he was drawing attention to the role of sport as a sort of capsule or live paradigm of any society. Games are fashions in the same way as clothes because they involve the sensory life of a society in a mocking and fictitious way. To simulate one situation by means

of another one, to turn the whole working environment into a small model, is a means of perception and control by means of public ritual. The audience as participants is indispensable to most games. The

greatest contest in the world in which only the players are present would have no game character whatever. The audience acts as the environmental cliché and the players enact the metaphorical archetype of the wider situation. This is a form of that anti-environmentalism which was previously discussed as indispensable to any culture that seeks to avoid complete somnambulism.

Such somnambulism is certainly not avoided by tribal man. Tribal societies have long been called "the people of the dream," precisely because they are locked in a collective awareness and avoid anti-environments rigorously. Charles F. Hockett and Robert Ascher in *Culture: Man's Adaptive Dimension* have a lengthy and valuable discussion of play in such societies:

"The Human Revolution," from Current Anthropology Vol. 5, No. 3, by Charles F. Hockett and Robert Ascher. 1964.

The development of an open, largely traditionally transmitted, vocal-auditory communicative system means that *verbal play* is added to play at fighting, sexual play, and any other older categories. But this, in turn, means that situations are being talked about when they do not exist—that is, it means the addition of displacement to the design features already at hand. Speaking of things which are out of sight or in the past or future is very much like carrying a weapon when there is no immediate need for it. Each of these habits thus reinforces the other.

To the contrary, Eric Berne, M.D., in *Games People Play,* states:

What we are concerned with here, however, are the unconscious games played by innocent people engaged in duplex transactions of which they are not fully aware, and which form the most important aspect of social life all over the world.

"Games People Play: The Psychology of Human Relationships," by Eric Berne, M.D. Reprinted by permission of Grove Press, Inc. Copyright © 1964 by Eric Berne.

In *Homo Ludens,* Johan Huizinga explores very much more valuable territory than Berne, namely, the creative role of play in all levels of art and society. Huizinga pursues this theme through the processes and structures of dialogue, political party systems, the struggle of the artist with his

materials and his audience, as well as the various forms of sport.

Games stand in relation to new technology somewhat in the form of clothing. Radio and baseball were well matched, but television has killed baseball and advanced football and ice hockey. Baseball was quite incompatible with the television spectator's role of participation in tactile depth. Baseball insists on careful timing and one play at a time. English cricket would be equally futile on television since its plays are much less frequent. Soccer, however, has had a huge revival with television quite apart from the television watcher. It has been the altered sensibilities of the whole culture in the bodily contact direction that have revived soccer. The new games of surfboarding, water skiing, and snow skiing are fascinating examples of a new taste for dynamic contour exploration in which the participant amidst the most exciting environment is almost entirely visceral rather than visual in his involvement. It can be safely predicted that color television will drive people much further in this direction, for there

When asked what music did he like, Mozart answered, "No music." Mozart was not a consumer. No artist likes art. He makes it.

Since alls war that end war let sports be leisure and bring and buy fair. FW 279.

"And I will purge thy mortal grossness s[o]
That thou shalt like an airy spirit go."

is a world of difference between color tele-
vision and black and white.

Huizinga in *Homo Ludens* explores the
deeply essential role of play as involving
our senses themselves in abrasive dia-
logue, using "play" in the sense in which
we speak of the "play" in a wheel or the
"play" of emotions or the "play" of ex-
pression. The absence of this kind of play
and flexibility carries us straight from the
world of enterprise to the world of bureauc-
racy. The world of play is necessarily one
of uncertainty and discovery at every mo-
ment whereas the ambition of the bureau-
crat and the systems-builder is to deal
only with foregone conclusions. Joyce
touches on this subject in his very play-
ful *Finnegans Wake*:

All our fellows at O'Dea's sages with
Aratar Calaman he is a cemented brick,
buck it all! A more nor usually sober
cardriver, who was jauntingly hosing his
runabout, Ginger Jane, took a strong
view. Lorry hosed her as he talked and
this is what he told rewritemen: Ire-
waker is just a plain pink joint reformee
in private life but folks all have it by
brehemons laws he has parliamentary
honours...*Mon foie,* you wish to ave
some homelette, yes, lady! Good, mein
leber! Your hegg he must break himself.
See, I crack, so, he sit in the poele,
umbedimbt! A perspirer (over sixty) who
was keeping up his tennises panted he
kne ho har twa to clect infamatios but
a diffpair flannels climb wall and tres-
passing on doorbell.

Real play, like the whodunit, throws the
stress on process rather than on product,
giving the audience the chance of being
a maker rather than a mere consumer.

A Message to the Fish

One thing about which fish know exactly nothing is water, since they have no anti-environment which would enable them to perceive the element they live in. It appears that they can hear pretty well but have scarcely any power of directional location for the origin of the sounds they hear. In some species they discharge electric shocks as a means of spatial orientation, much as bats use their high-pitched squeaks as the equivalent of flashlights. What fish are able to see bears a close analogy to that degree of awareness which all people have in relation to any new environment created by a new technology—just about zero. Yet despite a very limited sensory life, the fish has an essence or built-in potential which eliminates all problems from its universe. It is always a fish and always manages to continue to be a fish while it exists at all. Such is not, by any means, the case with man.

The order of importance in which we rate our existing senses will almost certainly change with electric technology and the computer. In his *History as a System*, Ortega y Gasset is quite aware of this:

"What rough beast, its hour come round at last, slouches toward Bethlehem to be born?"
—Yeats

Darwin believed that species equipped with eyes have been forthcoming in a millennial evolutionary process because sight is necessary or convenient in the struggle for existence against the environment. The theory of mutation and its ally, the Mendelian theory, show with a certainty hitherto unknown in biology that precisely the opposite is true. The species with eyes appears suddenly, capriciously as it were, and it is this species which changes the environment by creating its visible aspect. The eye does not come into being because it is needed. Just the contrary; because the

"History as a System and Other Essays Toward a Philosophy of History," by José Ortega y Gasset, with an afterword by John William Miller. Copyright 1941, © 1961 by W. W. Norton & Company, Inc.

Maris

"The world is trying to adjust to a new conception of man in relation to men."
—Skinner

eye appears it can henceforth be applied as a serviceable instrument. Each species builds up its stock of useful habits by selecting among, and taking advantage of, the innumerable useless actions which a living being performs out of sheer exuberance.

He notes:

For a man, on the contrary, to exist does not mean to exist at once as the man he is, but merely that there exists a possibility of, and an effort towards, accomplishing this. Who of us is all he should be and all he longs to be? In contrast to the rest of creation, man, in existing, has to make his existence. He has to solve the practical problem of transferring into reality the program that is himself. For this reason "my life" is pure task, a thing inexorably to be made.

In the present age this problem of not simply being human but of having to program the entire process has become a crux because of our electronic technology. The new potential is so great that no training for any individual or any society could faintly tap its possibilities. Life is not given to us ready-made but has become a task of making rather than of matching. There is no previous model, private or corporate, that can serve for the present time. That is why the anti-environment has become so indispensable a crux. We have simply got to create anti-environments in order to know what we are and what we are doing. Skinner approaches the matter from a different angle:

> "Isn't it time we talked about freedom?" I said. "We parted a day or so ago on an agreement to let the question of freedom ring. It's time to answer, don't you think?"

> "My answer is simple enough," said Frazier. "I deny that freedom exists at all. I must deny it—or my program would be absurd. You can't have a science about a subject matter which hops cāpriciously about. Perhaps we can never prove that man isn't free; it's an assumption. But the increasing success of a science of behavior makes it more and more plausible."

Unlike animals, man has no nature but his own history—his total history. Electronically, this total history is now potentially present in a kind of simultaneous transparency that carries us into a world of what Joyce calls "heliotropic noughttime." We have been rapt in "the artifice of eternity" by the placing of our own nervous system around the entire globe. The first

How good you are in explosition! How far-flung is your fokloire and how velktingeling your volupkabulary! FW 419.

PAN-OPTICAL PURVIEW OF POLITICAL PROGRESS AND THE FUTURE PRESENTATION OF THE PAST. FW 272.

satellite ended "nature" in the old sense. "Nature" became the content of a man-made environment. From that moment, all terrestrial phenomena were to become increasingly programmed artifacts and every facet of human life now comes within the scope of the artistic vision.

... at this rate of growing our cotted child of yestereve will soon fill space and burst in systems, ... FW 429.

Skinner saw quite clearly that human efforts to shape our lives are, so far, merely peripheral:

When men strike for freedom, they strike against jails and the police, or the threat of them—against oppression. They never strike against forces which make them want to act the way they do. Yet, it seems to be understood that governments will operate only through force or the threat of force, and that all other principles of control will be left to education, religion, and commerce. If this continues to be the case, we may as well give up. A government can never create a free people with the techniques now allotted to it.

Skinner is quite aware that it is futile to deal with effects without penetrating to causes:

"And the majority are in a big quandary," he said. "They're not on the road at all, or they're scrambling back toward their starting point, or sliding from one side of the road to the other like so many crabs. What do you think two world wars have been about? Something as simple as boundaries or trade? Nonsense. The world is trying to adjust to a new conception of man in relation to men."

Most people become alarmed at the thought of corporate decision-making for creating a total service environment on this planet. Is it not like fearing that a city

lighting system interrupts the freedom of the private citizen to adjust each light to his own preferred levels? Yet, whole environments can be programmed to accommodate the sensory preferences and needs of entire communities. Galbraith has some relevant comments on these macro-environments and controls:

Health, chalce, endnessnessessity! FW 613.

> Group decision-making insures, moreover, that almost everyone's actions and even thoughts are known to others. This acts to enforce the code, and, more than incidentally, a high standard of personal honesty as well. The technostructure does not permit of the privacy that misfeasance and malfeasance require.

So the technostructure, as a matter of necessity, bans personal profit-making. And, as a practical matter, what is banned for the ordinary scientist, engineer, contract negotiator or sales executive must also be banned for senior officers. Resistance to pecuniary temptation cannot be enforced at the lower levels if it is known that the opportunity to turn a personal penny remains the prerogative of the high brass.

Lo, the laud of laurens now orielising benedictively when saint and sage have said there say. FW 613.

The members of the technostructure do not get the profits that they maximize. They must eschew personal profit-making. Accordingly, if the traditional commitment to profit maximization is to be upheld, they must be willing to do for others, specifically the stockholders, what they are forbidden to do for themselves. It is on such grounds that the doctrine of maximization in the mature corporation now rests. It holds that the will to make profits is, like the will to sexual expression, a fundamental urge. But it holds that this urge operates not in the first person but in the third. It is detached from self and manifested on

Never slip the silver key through your gate of golden age. Collide with man, collude with money. FW 433.

behalf of the unknown, anonymous and powerless persons who do not have the slightest notion of whether their profits are, in fact, being maximized.

...he cursed and recursed and was everseen doing what your four-footlers saw or he was never done seeing what you cool-pigeons know,... FW 29.

The qualms of a highly individualistic and literate society about the effects of service environments extended to a terrestrial scale are, of course, rear-view mirror. The actual new effects from any new environment are only known to artists and they always come as a great surprise to the ordinary person. Galbraith once pointed out that the Negro truck driver was enabled to feel the equal of any white man because of the great extension of power under his foot. Literate men dread the repetitive servitude of factory life (Charlie Chaplin's *Modern Times*-style) without realizing that it was their own literacy that created this factory and that print technology is the archetype of all industrial life. When Galbraith said that the Civil War prolonged the institution of slavery, he had partly in mind the fact that the habits of the factory worker are quite incompatible with the Southern form of slavery.

In the introduction to the *I Ching, Book of Changes* (translated by James Legge), we find observations on the general law of transformation as a process of construction and destruction:

"I Ching, Book of Changes," translated by James Legge, edited with introduction and study guide by Ch'uchai with Winberg Chai. University Books, New Hyde Park, N.Y.

At the same time equating the constructive phase of this process with the "returning" and the destructive phase with the "going away." The complement to "going away" is "returning"; the unceasing process—from going to returning and vice versa—is designated as transformation. This going and returning has no end; in other words, there is

*Free me
and the
riches
of the
universe
will be
yours!"*

no returning without going and no going without returning. As is said, "Between Heaven and Earth nothing goes away that does not return."

One of the peculiarities of an electric technology is that it speeds up this process of transformation. Instant and total rehearsal of all pasts and all processes enables us to perceive the function of such perpetual returns as one of purgation and purification, translating the entire world into a work of art.

Accusative ahnsire! Damadam to infinities!
FW 19.

In his book *Propaganda,* Jacques Ellul elucidated the nature of propaganda not as the content of any particular medium or institution but as the total culture in action, a clear instance of macroscopic gesticulation. Another function of speed of rehearsal of cultures is that as one goes inside another the traits of each become vivid. Thus, in our time Jessie Weston's *From Ritual to Romance* is an example of macroscopic awareness over thousands of years. Ritual is a non-narrative form which literate man translated into a romantic narrative and which electronic man translates back into ritual.

Consistent with the drastic environmental changes from mechanical ritual to electronic romance is not only the reversal by which every civilian becomes a soldier once more, as in ancient Rome or on our own frontier, but many reversals besides. It is not only our educational system that cannot stand up to the new electronic speed of information movement. The stock exchanges of the world are just as helpless and will disappear under the impact of the computer in a few years. The large cities of the world are so obsolete and

He was down with the whooping laugh at the age of the loss of reason the whopping first time ...
FW 423.

And so everybody heard their plaint and all listened to their plause. The letter! The litter! And the soother the bitther!
FW 93.

irrelevant that they will all suffer the fate of London Bridge which has not fallen down but is to be taken down and transferred to the private property of a Texan. Within ten years New York will have been dismantled and the ordinary citizen will have returned to life on the land. There will be no roads and no wheels but only anti-gravitational transport. One of the paradoxical features of substituting software information for hardware machinery is total decentralization. It now applies to cities as much as to telephones:

"Two-Factor Theory, or How to Turn Eighty Million Workers into Capitalists on Borrowed Money," by Louis O. Kelso and Patricia Hetter. Random House, Inc. © Copyright, 1967, by Louis O. Kelso and Patricia Hetter.

> The planned optimum withdrawal of government from all but absolutely irreducible welfare functions should take place as second incomes flow to more and more consumer units. As the power to produce wealth is extended to all households and individuals in the economy, it will be less and less necessary to distribute wealth on the basis of need. To be sure, some private charity and public welfare may be required even in an economy that has virtually achieved general affluence. But the objective of economic planning in a universal capitalist economy is to reduce both the need for public welfare and private charity to an absolute minimum. Every individual's human dignity requires that he enjoy general affluence, and that he produce it.

Now that we are in the post-industrial time and moving into a world of programmed environments we are certain to become obsessed with the economic organizations that lie immediately behind us. Kelso and Hetter spot this syndrome in economist Galbraith:

Thus the unfacts, did we possess them, are too imprecisely few to warrant our certitude,...
FW 57.

> Mr. Galbraith, like many other economists, has formed his concept of afflu-

ence by comparing the United States with pre-industrial economies, less industrialized economies, or nonindustrialized economies. In that sense, but only in that sense, it may be said that the people of the United States are affluent. However, the poverty of the past is irrelevant to the industrial present; in terms of its productive potential, its rampant human need for an abundant stream of goods and services, and the eagerness of its managers, engineers, technicians, and scientists to unleash the productive power they know exists but which the economy cannot utilize, the United States is a grossly underdeveloped country. Under present economic misconceptions, it will remain underdeveloped, and even retrogress.

Since the electronic age inevitably drives us back into a world of mythic vision in which we put Humpty Dumpty back together again, as it were, it is well to disabuse ourselves of the "sense of myth" as unreal or false. It was the fragmented and literate intellectualism of the Greeks that destroyed the integral mythic vision to which we are now returning. The poet-painter William Blake was one of the forerunners of this awareness, but Giambattista Vico, the darling of James Joyce, preceded Blake in this awareness. The primitive poets had taken for granted that nature was opaque and its causes and effects obscure:

In the first place, the fables of the gods were stories of the times in which men of the crudest, gentile humanity thought that all things necessary or useful to the human race were deities. The authors of this poetry were the first peoples, whom we find to have been all theo-

Somebody may perhaps hint at an aughter impression of I was wrong. No such a thing! You never made a more freudful mistake, excuse yourself! What's pork to you means meat to me while you behold how I be eld. FW 411-412.

"The New Science of Giambattista Vico," by Thomas Goddard Bergin and Max Harold Fisch. © 1948 by Cornell University.

logical poets, who without doubt, as we are told, founded the gentile nations with fables of the gods.

To the preliterate man of integral vision a fable is what we would call a major scientific truth, and the entire scope of the new environments as macroscopic enlargements of our own self-amputations can today provide the beginnings of a new science of man and technology.

The integral mosaic vision allowed to the eye as vortex scans and includes both East and West:

for the eye recognizes everything, and so all directions enter into the eye: they are at home in it, and its vortex is truly encompassed. Such an eye sees the earth of imagination as "one infinite plane," unlike the weak, corporeal traveller who is confined beneath the world of Beulah in generative bondage.

This image of the vortex is illuminated in the subtle and central passage that follows:

"Blake's Apocalypse," by Harold Bloom. Doubleday Anchor Book.

First Milton saw Albion upon the Rock of Ages,

Deadly pale outstretch'd and snowy cold, storm cover'd.

A Giant form of perfect beauty outstretch'd on the rock

In solemn death: the Sea of Time & Space thunder'd aloud

Against the rock, which was inwrapped with the weeds of death.

Hovering over the cold bosom in its vortex Milton bent down

To the bosom of death: what was underneath soon seem'd above:

A cloudy heaven mingled with stormy seas in loudest ruin;

But as a wintry globe descends
 precipitant, thro' Beulah bursting
With thunders loud and terrible, so
 Milton's shadow fell
Precipitant, loud thund'ring, into the
 Sea of Time & Space.

Where else can you
sleep in a Malay temple,
eat in an Italian villa, get a tan
and go on a safari?

A Further Message to the Fish Fresh Out of Water

The "End of Nature" theme may well require a footnote. It can be provided very conveniently by Ernst Mayr's *Animal Species and Evolution:*

"Animal Species and Evolution," by Ernst Mayr. The Belknap Press of Harvard University Press.

...a world in which there are no species, but only individuals, all belonging to a single "connubium." Every individual is different from every other one in varying degrees, and every individual is capable of mating with those others that are most similar to it. In such a world, every individual would be, so to speak, the center of a series of concentric rings of increasingly more different individuals. Any two mates would be on the average rather different from each other and would produce a vast array of genetically different types among their offspring. Now let us assume that one of these recombinations is particularly well adapted for one of the available niches. It is prosperous in this niche, but when the time comes for mating this superior genetic complex will inevitably be broken up. There is no mechanism that would prevent such a destruction of genetically superior combinations and there is, therefore, no possibility of the gradual improvement of genetic combinations. The significance of the species now becomes evident. The reproductive isolation of a species is a protective device against the breaking up of its well-integrated, co-adapted system.

The self-amputations of man (the extensions of his body and, most recently, his

190

nervous system), which we call technologies, can be substituted throughout this passage for the word "species." Today, the new species are, thanks to the speed-up of intercommunication, those environments which had formerly been habitats. All media or technologies, languages as much as weaponry, create new environments or habitats, which become the milieux for new species or technologies. The evolutionary habitats of the biologists since Darwin were the old nature which has now been transcended by satellite and radar.

The biologists use two other categories that are helpful for perceiving the relation between the end of nature today and the problem of understanding the future of media and technology. They speak of "outbreeding" and "inbreeding." As Mayr puts it, "Most animals are essentially outbreeders, most microorganisms inbreeders."

Responding to first-night cheers of "Author! Author!", G. B. Shaw went before the curtain only to be greeted by a lone boo. He replied, "My dear fellow, I quite agree with you, but what are we two against so many?"

With electricity, all this has changed totally. At present the entire mammalian world has become the microorganismic. It is the total individual cultures of the world, linguistically and politically, that have become the mammals, according to the old classifications of evolutionary hypothesis. It is the cultural habitat in which we have long been accustomed to think that people were contained that has now become the mammal itself, now contained in a new macrocosm or "connubium" of a super-terrestrial kind. Our technologies, or self-amputations, and the environments or habitats which they create must now become that matrix of that macrocosmic connubial bliss derided by the evolutionist.

Credits

Lead, kindly fowl! They always did: ask the ages. What bird has done yesterday man may do next year, be it fly, be it moult, be it hatch, be it agreement in the nest. FW 112.